STREET ARTISTS

Graffito Books
32 Great Sutton Street
Clerkenwell
London
EC1V 0NB
UK

www.graffitobooks.com

Production Yahya El-Droubie
Editorial Assistant Mary Gallagher

Printed in China

ISBN: 978-0-9560284-1-9

British Library cataloguing-in-publication data
A catalogue record of this book is available at the British Library

STREET ARTISTS

THE COMPLETE GUIDE

by Eleanor Mathieson and Xavier A. Tàpies
Photography by Glenn Arango

GRAFFITO

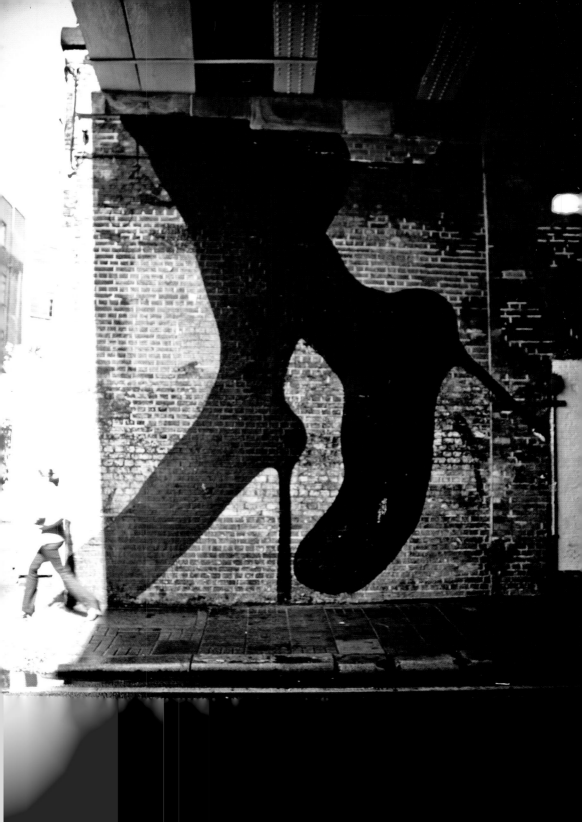

CONTENTS

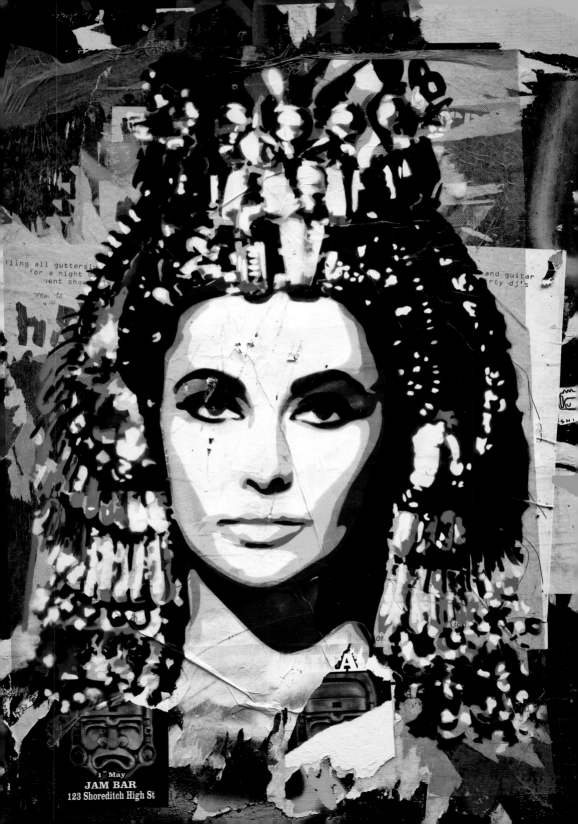

INTRODUCTION

Anyone who doubts that street art is one of the most, if not the most significant art movements of our times, need only take a walk through London, New York or São Paulo and pause to look at the work that has been created on its walls. Ranging from photocopied scribbles to complex stencil or hand-painted pieces, the work displays a spectrum of uncensored talent that is immediately put in front of an audience, ready to be liked, loved, hated, judged or simply ignored.

Still not fully convinced of the impact of street art as an art movement? Look at Sotheby's records or the collections of some of the world's major art galleries. The former would reveal the record price achieved for a Banksy: US$1.9 million in 2008. A walk around the MOMA New York or Tate Modern in London would reveal Shepard Faireys, more canvases from Banksy and works by Swoon.

It was inevitable that the rapacious art market would twig that some major talents had emerged from a street scene that had its origins in 1970s New York and which really exploded into popular consciousness in 2003. Ironically, the motivation for these artists was not having to worry about whatever the art establishment, the major galleries and the critics (in the words of Dan Witz, "Fat, bald white guys in their 50s") had decreed was worthy of the tag 'Art'. The creative spirit would not be held down. In the favelas of São Paulo, Brazil, for instance, the whole city was turned into a canvas of *Pixação*, with usually teenagers risking their lives to express. Now, of course, the work is almost respectable and a spur to tourism, but then it was a

case of risking falling off a high building or getting shot at by trigger-happy police.

In this harsh environment it is the public who choose what they respond to, photograph or point out to friends, not a curator who puts work in front of an already-primed audience. Unlike graffiti, where the work is intended to make sense to a peer group, street art is open to everyone to understand. In the West the creative spirit on the street found an anti-authoritarian purpose. From Blek Le Rat, the first significant stencillist (from a bourgeois background but radicalised by his art teachers in the 1970s), to Banksy, who used his brilliance to highlight the plight of the Palestinians, street art developed a visceral energy precisely because it was free, couldn't be bought and if eradicated would simply re-appear a few days later. Its role in articulating opposition to the illegal war on Iraq was particularly important in the face of a media which essentially had been 'bought'.

The results are a startling redefinition of what art can be. Some cities, like Barcelona, encouraged the art early on. Many now recognise how square they were in trying to eradicate it, and are making it part of their tourism offer. The galleries are forever trying to persuade these artists onto canvas. It is the artistic phenomenon of our times, with hundreds of brilliant practitioners. Here we've included 50 of the best, which will no doubt lead to disputes as to why x or y was left out. We look forward to that discussion: it's further proof of how vibrant the scene and its adherents still are.

ABOVE

Handcuffed ten times by police in seven different countries, Above (his identity is still secret despite installing much of his art in broad daylight while wearing tradesmen's overalls), was born in about 1981 in California.

He started tagging his neighbourhood freight trains with the word Above in 1995. Three years later, frustrated that he couldn't read his tag on speeding trains, he developed the instantly-recognisable upwards-pointing arrow and a new street art phenomenon was born. "The arrow represents Above, but also the mentality to rise above, you can also interpret it as you like".

In 2001 Above began his international travels with a move to Paris, with its thriving street art scene which at the time included Invader, Stak, André and Honet. Central to many of these artists' work was the use of a logo which would crop up all over the city. Above developed his arrow from a simple stencil, to pre-prepared wooden arrows, which he would place high on walls. In time he covered all of Paris's 20 *arrondissements* with over 500 arrows.

In 2003, with a return to California, his art acquired a whole new dimension: mobiles. The first painted wooden arrow mobiles were hung from telephone wires in San Francisco and L.A.. There followed the first of his 'art tours', along the West Coast, with arrows hung in San Diego, Santa Fe, Reno, Taos and Albuquerque.

Always developing his work, Above

BELOW: A large scale wall piece featuring Above's iconic arrows (seen directly opposite Barcelona's MACBA in 2005).

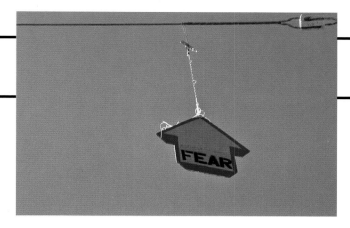
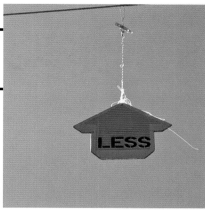

introduced word-play into the mix in 2004. At every point the arrows were hung high, sometimes in seemingly impossible-to-reach places. Suggestive words on the arrows were matched to a location. The purpose of the arrows was "to evoke a curiosity as to What? Why? Who? and How?"

Hanging arrows in the US was straightforward due to the myriad telephone and power wires (Above was once electrocuted while installing his work). His European Tour of 2005, covering 15 countries in four months, marked an evolution of the wooden arrow – this time using fabric and wood – attached to walls as before. The 2005 tour allowed him to research potential locations for mobiles, and to plan for a 2006 Sign-Language Tour.

This tour, again taking place in Europe, involved massive preparation, cutting the arrows, glueing fabric to the arrows, screenprinting the colours and stencilling on suggestive words. Spinning with contrasting words on each side, these would provoke or amuse the viewer, creating a dialogue.

In advance of the tour hundreds of arrows were shipped to Barcelona. Once in Europe, Above wandered the cities at night in order to see which word plays would work in which locations: "I would think of word plays that would relate to a certain environment or structure of a city."

So in Amsterdam arrow mobiles were hung with the word plays sex/shop; red/lite; burn/weed. In other cities, at busy

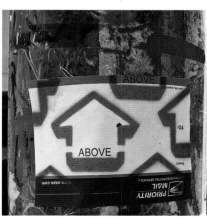

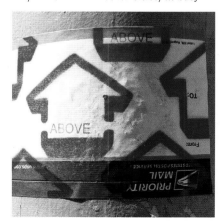

ABOVE

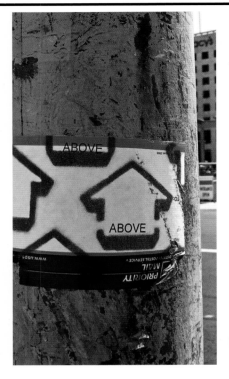

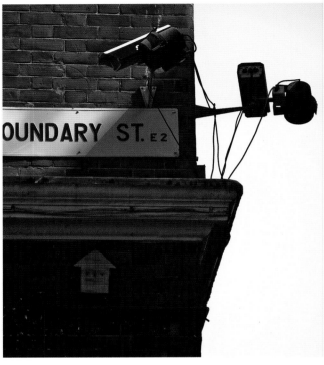

crossroads, he might use honk/horn; in intimate corners the word play nice/eyes.

The Sign-Language Tour over, with art having been created in 26 cities (including a fake Eurail pass that got him around), Above decided on Central and South America for his next travels. The ambition was now to use longer words and sentence constructions, and to paint large-scale murals.

The tour began in Rio, and covered 13 countries including Argentina, Chile and Mexico. The result was some brilliant word-play murals, such as the one from 2008 in Guatemala City, *By The Time You Read This I'll Already Be Gone*, or the clever mural palindrome

AMANAPLANACANALPANAMA that he painted in Panama City.

With this new work the arrow disappeared "I had been painting arrows for five years and I wanted to showcase and explore new mediums, talents...and challenges." In its place came figurative stencil work, of a more directly political nature, sending up AIG executives, or the hooded bank robber painted by a hole-in-the-wall cash machine. The talent for situation remained: a piece showing the graph of the 2008/09 collapse in the stockmarket was painted on a Washington Mutual bank wall, with the graph's line extended across the pavement and down the edge of the kerb into a sewer.

ABOVE LEFT: Another postal label featuring the Above arrows (San Francisco, 2002).
ABOVE RIGHT: A card arrow points out security cameras in East London.

ANDRÉ

RIGHT: A running Mr. A seen on Clerkenwell Road, London in 2005. **BELOW:** Mr. A mixes it up with one of Banksy's classic rats in Shoreditch, London (taken 2003).

Nightclub owner, hotel owner, clothing designer and international party boy André Saraiva leaves a visible trail of his nocturnal activities in the form of his Mr. A character. Long-legged, grinning, human-sized Mr. A's can be seen on walls in London, Paris, New York, Tokyo and L.A., tracing the path of André's entrepreneurial and social engagements.

"Mr. A is my guardian angel, my shadow, my alter ego and my friend. He follows me everywhere...and helps me find my way back. He is my trail, like Hansel and Gretel's bread crumbs" says André. André has been painting since 1985, starting out in Paris (he was born in

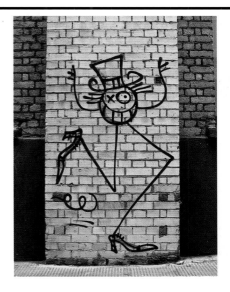

Sweden but brought up in the French capital), where he developed the Mr. A character and started populating his home city's streets with his top hat-wearing persona.

Some of the best renditions of Mr. A see him interacting with the streets in which he appears, his feet painted to sit just above the pavement, so it looks as if he is walking or running along the street, or his arm reaching around a drainpipe to ring on a doorbell. With these works you can imagine that the spray-painted Mr. A could easily peel off the wall and start walking.

A 2009 collaboration with Belvedere Vodka XI saw a specially designed Mr. XI character (the twin of Mr. A but with XI for eyes and a hot pink hue) animated in a short film doing exactly this. In the film, Mr. XI springs to life after being sprayed onto a wall by André, and joins André for a night out at his usual New

ANDRÉ

York haunts, at one point pouring himself a vodka and draping his arm around a scantily-clad model.

The brand-association made the most of André's influence on the nightclub scene, as a partner in Paris nightclubs, Le Baron and Paris Paris, and the Beatrice Inn in New York. It also raised the question of 'selling out', an accusation thrown at street artists who are seen as losing credibility by working with companies who want to buy into street authenticity.

André's business model allows him to make a living from his graffiti without going the traditional art dealer route. By working with companies, André does not have to translate his work into a gallery environment, where it could easily be stifled, as its impact is based on the interaction between the art and the location in which it is placed.

André is practiced at monetizing his graffiti work. From 1997-2003 he worked on the *Love Graffiti* project, where people could pay him $2,500 to spray paint the names of their lovers in a location of their choosing. He painted his own *Love Graffiti* for fiancée Uffie in Hollywood, L.A. in December 2008.

André's continued attraction to rule breaking (he still does graffiti but not in Paris, where he has been caught by the police too many times) makes him more complex than the typical slick businessman. Described in the *New York Times* as a "social alchemist", as well as running his nightclubs across three continents (Le Baron now has a Tokyo outpost), André is also partner

RIGHT (clockwise from top left): A classic Mr. A near Hoxton Square, London, seen in 2001. // A more recent Mr. A head seen in Harajuku, Tokyo in 2008 keeping an old (2001) Space Invader company. // Mr. A on Clerkenwell Road in London in 2005. // Mr. A ringing a doorbell behind Kingsland Road in East London, taken in 2005. // A Mr. A Head found on a power locker on Hong Kong Island in 2004. // Mr. A scrawled on a pedestrian bridge over Tokyo's Omotesando Dori, taken in 2004. **BELOW:** A large Mr. A head adorns a door on Los Angeles' La Brea Ave in 2004.

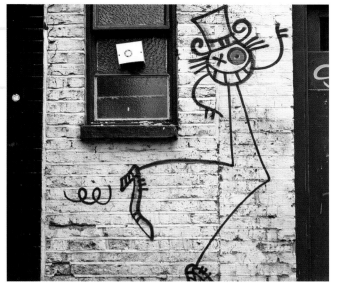

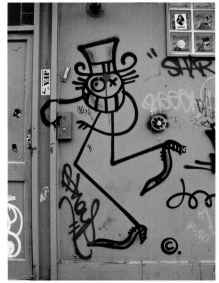

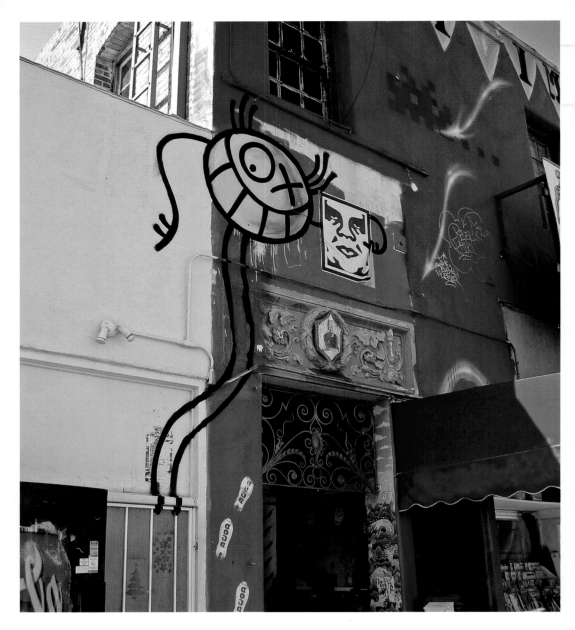

in L'Hôtel Amour, Paris, organises 'Le Baron' parties on the art fair circuit (at Frieze, the Venice Biennale and so on) and has produced a nightclub magazine *Wow*, and a clothing line 'Andréwear'. But he still sticks to the idea that "graffiti is not vandalism, but a beautiful crime."

Despite his success, his nightclubs and his corporate deals with big brands, dressed in a leather jacket and wearing his ubiquitous sunglasses André maintains an air of Parisian nonchalance. Watching the YouTube video of him painting a huge graffiti piece reading "I just don't give a fuck", somehow we still believe him.

ABOVE: L.A. 2004 – Mr. A embraces Shepard Fairey's Andre the Giant as a Space Invader swoops overhead.

BANKSY

BELOW: *Laugh Now But One Day We'll Be In Charge* – a classic Banksy seen in Soho, London, in 2001. **BELOW RIGHT:** Another early, single-sheet stencil, also seen in London's Soho in 2001.

Now embraced by the upper echelons of the art establishment, Banksy is arguably the most influential, provocative and inspiring artist from the street art scene, and possibly any art scene in the noughties. His ability to treat the street as a canvas to project his anti-war, anti-capitalist and generally anti-establishment views is unsurpassed, and the sheer technical skill and visual wit of his satirical pieces, or his moving highlighting of the plight of oppressed peoples, forced street art to be recognised, even by those who wished to wipe it from the face of the earth, as the meaningful art form of our times.

Little is known about him, for Banksy has made an art out of exploiting his anonymity in the most tongue-in-cheek manner. Even his agent, Lazarides, claims not to be entirely sure: Banksy will let him know in which out-of-town carpark he's left a new set of canvases for his next show.

Born in Bristol in the mid-seventies, and part of the Bristol graffiti scene, which included DBZ (DryBreadZ Crew), he turned to stencils in 2000 as a way to effect his 'pieces' at top speed. In his

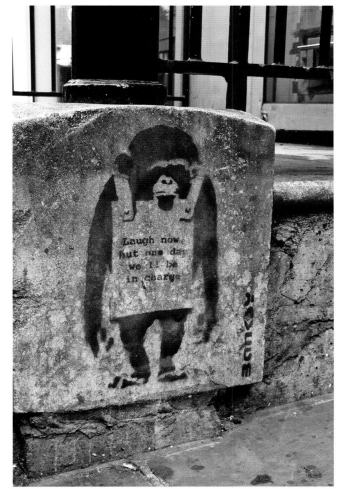

BANKSY

use of stencils he has acknowledged Blek Le Rat (Xavier Prou) as a major inspiration, stating that "every time I think I've painted something slightly original, I find out that Blek Le Rat has done it as well, only twenty years earlier."

This is Banksy in typically modest vein. Whilst Blek may have been the inspiration, the design quality and use of satire that Banksy brings to bear on his art is all his own. Every piece seems to share the quality of an instantly memorable humorous or satirical or poignant 'hit', which kicks around in your memory, making you think again.

Banksy's work began to pierce popular consciousness in 2001, following a trip to Australia, where he met visual activist and pastellist James DeWeaver

in Byron Bay. This was the year that he self-published his first book *Banging Your Head Against a Brick Wall*. By publishing, Banksy was already declaring that his street art needed to be significant way beyond the street.

In 2002 Banksy held his first US show at the 33 1/3 Gallery in L.A., and with it he published his second book, *Existencilism*. The stage was set for 2003, the year that Banksy dodged Israeli army bullets to paint his amazing pictures on the West Bank wall which turned Palestine, in his words, "into the world's largest prison".

The eloquence with which Banksy highlighted the plight of the Palestinians, with unforgettable images of idealised scenes of childhood, freedom and ease which the West takes for granted, in

RIGHT (clockwise from top left): ATM, Clerkenwell, London, as seen in 2007. // Life-size kissing coppers, Soho, London, seen in 2003. // Faded *No More Heroes* piece on Melrose Ave, L.A., a leftover from Banksy's 2006 Hollywood art show (taken 2008). // Hoody at Cans Fest, London, 2008. **BELOW:** This well know Banksy at London's Marble Arch (there since 2005) shows his fascination with CCTV cameras (taken 2007).

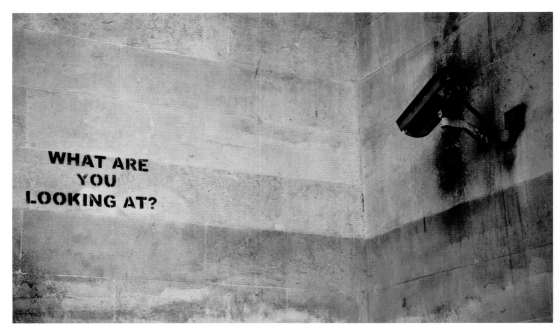

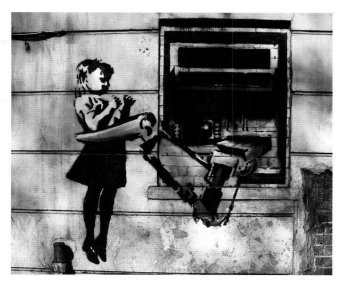

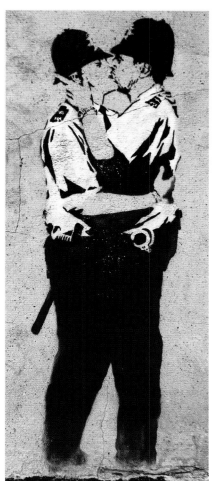

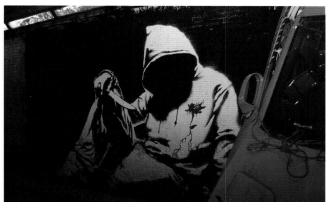

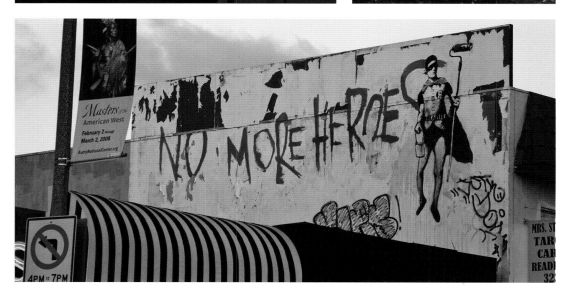

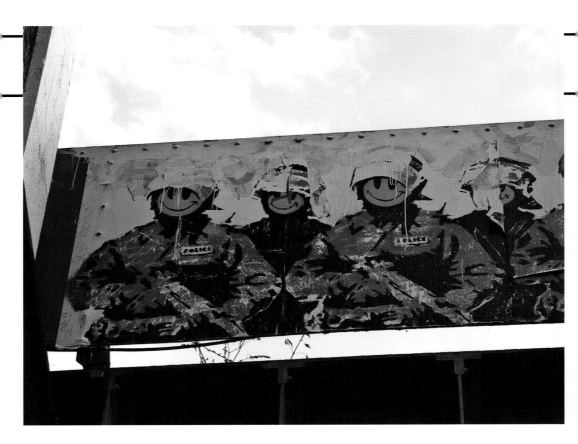

one bound elevated street art to a form of protest of international political importance. The West Bank pictures were also testament to Banksy's grand ambition. He thought that with the West Bank Wall one could "turn the world's most invasive and degrading structure into the world's longest gallery of free speech and bad art", adding "besides, I love Palestine".

The bigger the subject, the more powerfully he responded to it. Homophobia in the London Police force was highlighted by stencils of two policemen snogging. The growth of the surveillance society was referenced in his famous mural *One Nation Under CCTV* and the brilliantly cheeky statement in full view of a surveillance camera *What Are you Looking At?*, a challenge to

both the authorities and the viewer to be more aware of creeping surveillance fascism. A series of murals of London riot policemen, wearing anonymous happy faces, highlighted the hypocrisy of a government only pretending to allow free speech. Powerfully anti the so-called 'War On Terror', Banksy made his point with a brilliant piece of interventionism – smuggling a blow-up figure dressed in a fluorescent orange Guantanamo Bay prisoner suit with a black bag over its head, into a ride enclosure at Disneyland. Once again Banksy was pricking the West's conscience – whilst the West plays, prisoners were being detained illegally in a clear abuse of the state's power, without knowing the charges against them.

Banksy's work fiercely critiques other

ABOVE: Happy riot police in Shoreditch, London, across from the Old Street police station (taken in 2003). This piece evolved over two years with multiple message banners attached to it.

BANKSY

BELOW LEFT: Buddha with a neck brace and bandaged hand at the Cans Fest in 2008. **BELOW RIGHT:** A Banksy fan has 'enhanced' this smiling cop near Old Street tube station in London (taken 2005).

aspects of Western culture. A graffitied elephant for the 2003 *Turf War* show in L.A. pointed out how the West completely ignores the third world. In a parody of the cult of shopping, a Michelangelo-esque Virgin is shown in mourning by a sign saying 'Sale Ends Today'. Celebrity culture is attacked in a parodic pregnant Britney image, and he replaced 500 CDs by Paris Hilton

with doctored Banksy versions; new artwork included the statement: 'Every CD you buy puts me even further out of your league'. A sidewalk in L.A. was stencilled with the words 'FAT LANE'. Mickey Mouse and Ronald Macdonald are shown laughing on either side of a Vietnam War image of a child running from a napalm explosion. Whenever one tries to pigeonhole Banksy he surprises. Having conquered the street, the West Bank, London, he then decided it was time to subvert the galleries themselves. 2004 saw him hanging a Mona Lisa with a smiley face in the Louvre in Paris, followed by a similar 'short-cut' stunt at Tate Britain in London. The invention is endless.

In 2006 Banksy began to attract his own massive celebrity endorsement. Christina Aguilera bought an original stencil of Queen Victoria (who famously said she didn't believe in lesbianism), engaged in a lesbian act, for £25,000. Sotheby's the same year sold some silkscreens of Kate Moss in the manner of Warhol for £50,400. Prices continued to rise in 2007, with *Bombing Middle*

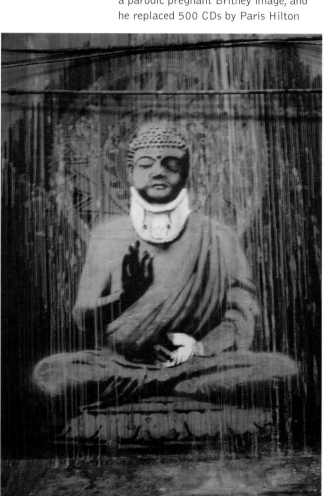

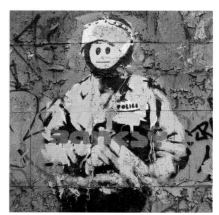

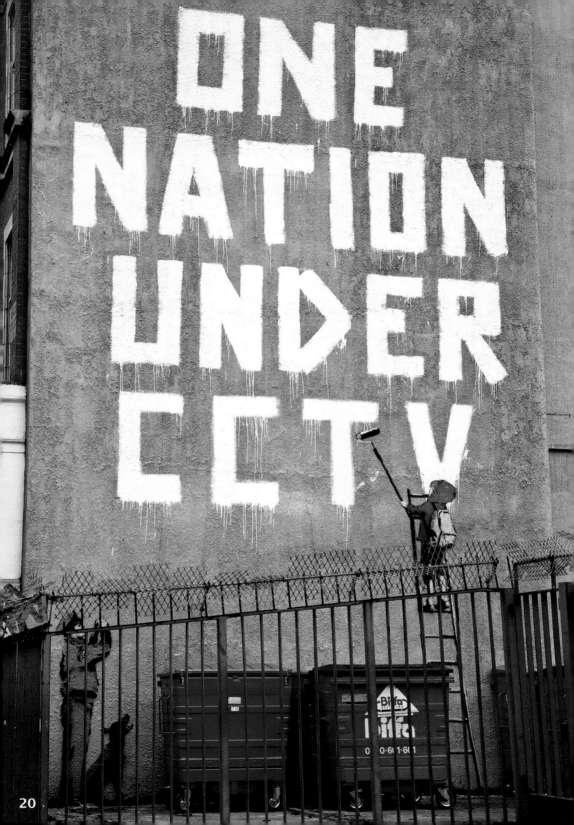

BANKSY

LEFT: One of Banksy's most brazen pieces just north of Oxford Street in Central London. Not only was this piece three stories tall, it was also done inside a Royal Mail facility parking lot and in plain view of the lot's CCTV camera (2008). **BELOW LEFT and RIGHT:** Details of the security guard and boy artist.

England achieving £102,000 at auction. Brangelina and Jude Law bought works; In 2008 his *Keep It Spotless* achieved US$1.9 million at Sotheby's New York. Banksy had himself become the subject of an establishment shopping spree.

Yet, characteristically, in May 2008 he responded with his most ambitious project yet. Hiring a disused street tunnel from train operator Eurostar under London's Waterloo Station, Banksy launched the Cans Festival on Leake Street. Acting as artist, curator and producer, he invited a host of top artists from around the world, including Blek Le Rat. There was no commercial exploitation however: no prints were on

BANKSY

sale, and areas were reserved for new artists.

Returning to his home town, 2009 saw Banksy launch his biggest show yet, at the Bristol City Art Museum. The *Banksy vs Bristol Museum* show had the playfulness, social commentary and ridiculing of authority figures featured in his early work. And yet one can't escape the fact that it looks like Banksy has finally been tamed, brought inside municipal gallery walls. The fun is still there – the show is rated "PG – Contains scenes of a childish nature some adults may find disappointing" – but when the Town Council, as in Bristol, slaps preservation orders on your graffiti, it's hard to keep an edge.

LEFT: A single sheet Banksy stencil as seen in London's Soho in 2001. **BELOW:** Banksy shows more interest in graffiti removal in this 2008 piece painted at London's first Cans Festival (2008).

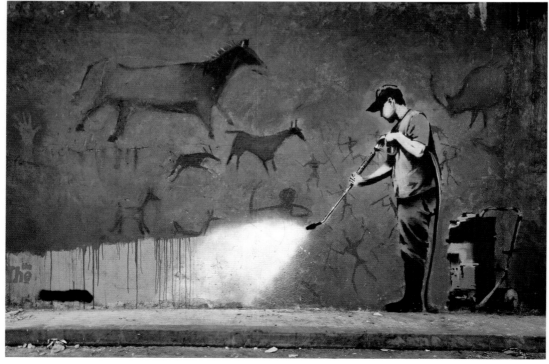

BÄST

Bäst's photo collage-style paste-ups and stencils have been seen on the streets of New York and Europe since the early noughties. Little is known about the artist, other than that he is Brooklyn-based and has collaborated with other New York street art stalwarts Faile. He shows Pop Art sensibilities in his choice of subject matter – advertisements, Disney cartoon characters, weapons, celebrities – and in the screenprinted, layered and distressed style in which these images are presented, often in black and white, or with simple

ABOVE RIGHT and BELOW: A pair of recent Bäst pieces found on the same wall in East London (2008).

colourways. The work often looks photocopied, or roughly printed, with simple block colours, giving it a cheap, rough, mass-produced feel which echoes flyposters or faded billboard advertisements. The works tend not to have a clear or direct message. Images and words taken from magazines, posters and advertisements appear to be collated at random, grouped together without a theme, but are frequently accompanied by the artist's own name.

Shepard Fairey talks about discovering Bäst's work, saying: "I found myself frustrated trying to interpret it, but amused by the idea of the aggravation it might cause an uptight person. In the end I just accepted the work as a pop culture regurgitation that added beautiful texture to the street and stimulated a free association in the viewer that may not have anything to do with Bäst's inspiration or intention. Bäst's images look somewhat random, which in turn makes the work feel very punk and a bit nihilistic, but the design sense is very pleasing and I'm sure considered. I would call the overall feel

BÄST

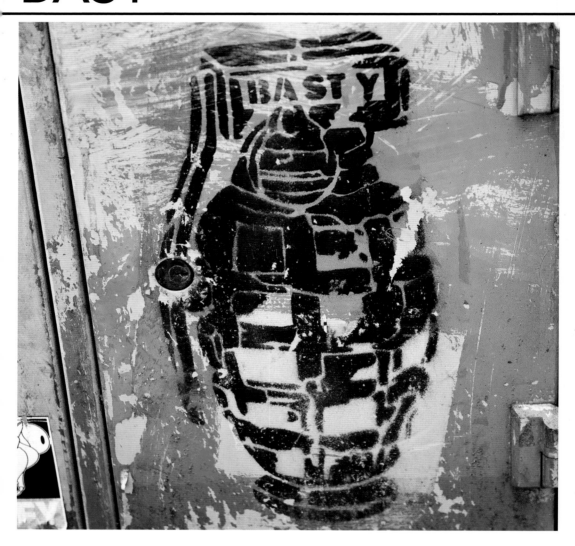

'organized chaos' in the same realm as Rauschenberg but using the street as the canvas."

When stumbling across posters which are peeling off the walls, and faded, in the same way as first encountering the Obey logo, the viewer could easily accept Bäst pieces as an advertisement, or a layering of advertisements, before closer inspection shows that the meaning is jumbled and images and words are being presented without anything being sold or any explicit point being made.

One of Bäst's most resonant images – *Holy Paris* – an image of Paris Hilton with holes punched through it, can be

ABOVE: An old grenade stencil seen in Shoreditch, London, 2007.

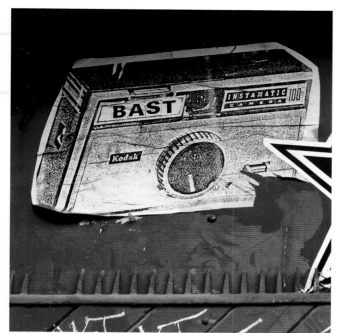

However, Bäst's 2008-2009 gallery and print works maintained the vitality of the street pieces. The print works featured vibrant, messily applied colour, glitter and texture, on top of images of cartoon characters like the Smurfs, Mickey and Minnie Mouse holding weapons.

Bäst has also produced scary sculptural animal masks (including a gorilla and pig wearing jewel-encrusted baseball caps, sporting gold teeth and loaded down with bling), and acid-coloured punk-style collages.

Work for a 2009 show *Horse Radish* saw Bäst use vintage magazine clippings, giving the pieces colour and texture reminiscent of Eduardo Paolozzi's collages from the late 1940s, portraying a fucked up/remixed version of the world.

ABOVE: Bäst piece co-branding a Kodak instamatic camera, Shoreditch, London (taken 2005). **RIGHT:** Multiple pasted-up snippets tied together with paint to make a single piece on this door in Lower Manhattan, NYC (taken 2001).

seen to have a more direct meaning, however, as a literal interpretation of the worship of celebrity.

In place of a message, Bäst's work tends to evoke a feeling. The decayed and distressed nature of the paste-ups, and the locations in which they are applied (down back alleyways or on faded doorways), combine with the everyday subjects of his work to create a sense of familiarity and nostalgia.

Bäst places his work in obscure, often unfrequented locations within the city in which he is working (be it London, Tokyo or New York). Discovering a piece is frequently an intense, one-on-one encounter, which adds to the work's subtle emotional impact.

As a street artist who is so rooted in the city of New York and its exterior spaces, one might think that the transition to off-street work would prove difficult.

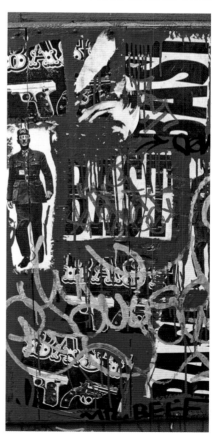

BLEK

Unquestionably one of the most significant figures in the development of street art into a global phenomenon, Blek le Rat achieved a massive breakthrough when he invented the life-sized stencil: suddenly, rather than simply decorating the city, ghostly street art characters could seem to be taking it over. What is astonishing is that he did this in the 1980s, and, even more surprising, that he didn't start creating graffiti until he was 30.

Born Xavier Prou in 1952, in an *haute bourgeois* suburb of Paris (his father was an architect, his mother the daughter of a French diplomat), he followed in the tracks laid by his privileged background, studying etching, lithography and painting at the École National Supèrieure des Beaux Arts, and then went on to architecture school. This was, however, only just post-1968 and Blek describes his teachers as "Trotskyites". Newly sociologically aware, with an interest in challenging the status quo, a

BELOW: Classic paste-up stencils share this wall under London's Waterloo Station as part of 2008's 1st Cans Festival in London.

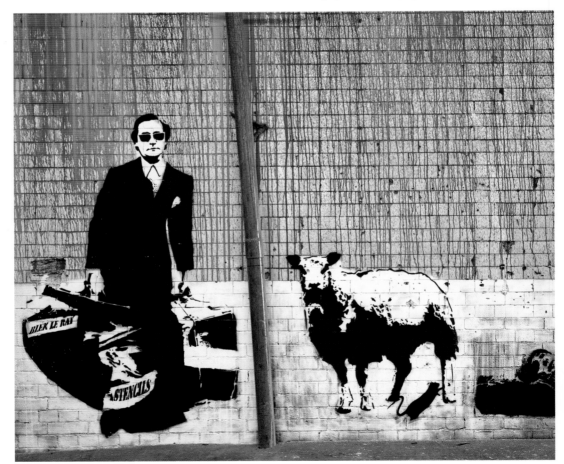

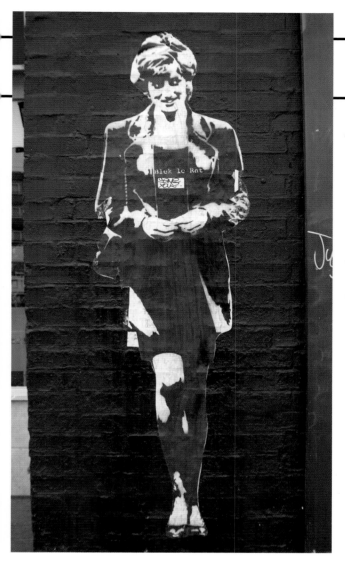

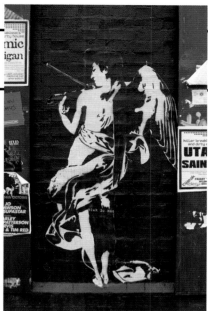

day on he decided to focus on stencils.

So he started with rats, sprayed first on the subways of Paris's ring road, the Périphérique, and continuing with hundreds more rats, seemingly migrating towards the centre. Blek was unleashing a plague of street art on the city. Each piece was signed by 'Blek le Rat', a moniker drawn from some US comics he had as a kid, featuring a character from the US War of Independence called 'Blek Le Roc'; the notion of 'Rat' being an anagram of 'Art' also appealed.

ABOVE: Princess Diana shares wall space with a cherub in these two paste-ups, seen in Old Street, London in October 2006.

trip to New York in 1971 was formative: "at that time Basquiat and Keith Haring were not known in France...I told my friend J.R. in Paris about the writing in the subway and streets of New York and he said 'that is a fucking great idea.'" At first he tried NYC-style graffiti in France, but felt it didn't ring true. The spark came with a recollection of some WWII stencilled graffiti he had seen of Mussolini's head on a trip to Paloma, Italy as a child. The propagandist element appealed to him and from that

His first life-sized figure was of an Irish tramp in a flat cap, then of a Greek widow in black. A host of now well-known characters followed, including his Diana with that minx look, created after she appeared to him in a dream begging him to stencil her. More controversially, he created his figure of Michelangelo's *David* holding a kalashnikov to show his support for Israel. Even with such an overtly political message, Blek injects his work with a humour that somehow makes it doubly effective, and

27

BLEK

it is this which has also been such an inspiration to a host of younger artists, not least Banksy. In a frequently-quoted statement, Banksy declared: "every time I think I've painted something slightly original, I find out that Blek Le Rat has done it as well, only twenty years earlier."

In 1991 Blek was arrested by the police, stencilling a copy of a Madonna and Child by Caravaggio on the Champs Elysèes in Paris. The case lasted a year and resulted in a shift in his work – from stencilling directly onto walls to pasting stencil posters. He now says he prefers working this way – it's faster and "not an aggression for the wall."

Blek has no doubt as to the importance of street art: "my stencils are a present, introducing people to the world of art, loaded with a political message. This movement is the democratisation of art: if the people cannot come to the gallery, we bring the gallery to the people!" He no longer thinks of himself as a rebel: city authorities, he says, should just recognise that the young have a need to create and instead of trying to repress this urge, they should provide walls for it to happen. What is revolutionary, he thinks, is the explosion in the street art movement: "this is just the beginning..... street art is going to be more global than any art movement has ever been."

Where Banksy declared his debt to Blek, so Blek has acknowledged how interest in Banksy has generated much greater interest in his own work. In 2008, Blek took part in Banksy's Cans Festival in London and the same year published a best-selling book of his own work. The cover carried one of his most abiding images – a life-sized Blek in shades and a black suit, carrying large leather suitcases filled with stencils, looking very much the busy, cool, pukka international traveller. A sign that street art has finally come of age? Perhaps.

BELOW: A Blek self-portrait paste-up (the image featured on the cover of his 2008 book) adorns the façade of an East London bookstore. The piece has been modified to include a garlic necklace and French flag (taken 2008).

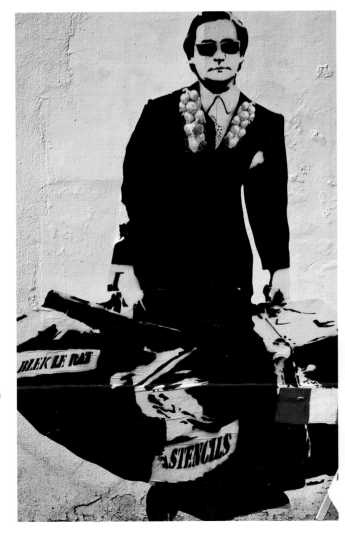

BLU

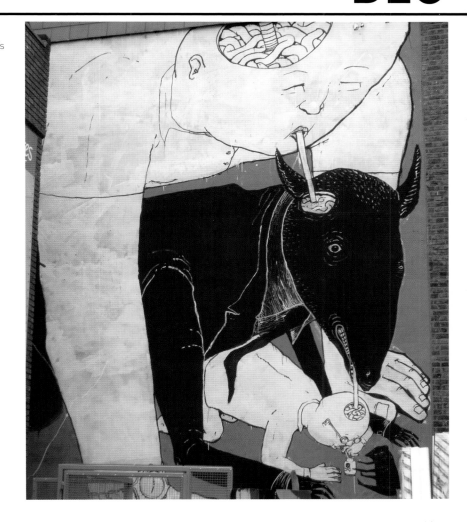

Hailing from Bologna, Blu has been producing building-sized murals in Europe and South America since 2000. His work has evolved into a strong, line-drawn style with an appealing cartoon-like simplicity and sometimes a mythological aspect.

The people and animals who feature in his work are often engaged in acts of physical violence and gut-wrenchingly fleshy interactions. In one piece in Old Street, London, Blu portrays a giant Buddha-like man, with the top of his head removed, and a straw placed in his brain, sucking on a straw that is placed in a hole in an animal's head, who, in turn, sucks from a straw poking into a smaller man's head — a revolting cycle of feeding painted in an appealing, approachable style. Despite the visceral nature of the acts depicted by Blu, this

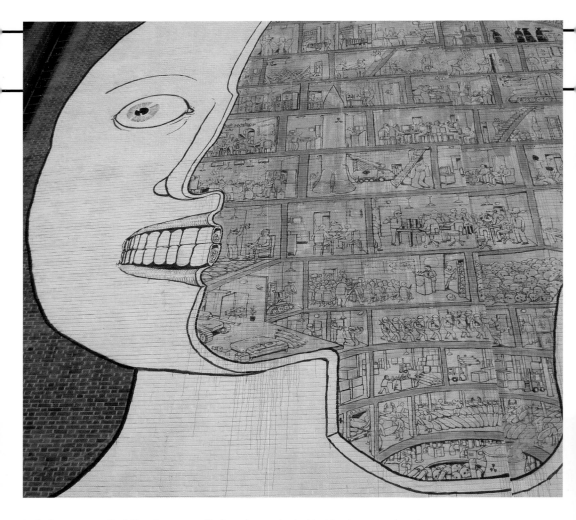

technique means that the viewer can find themselves fully engaged with the work before they have a chance to recoil from its gory content.

Blu is described by his gallery, Lazarides, who sell his small-scale sketches and prints, as an expert in "appealing horror" whose "interpretations of the human internal workings echo perverse practitioners such as infamous fetish illustrator Dolcett". However, while Dolcett is an illustrator specialising in the portrayal of extreme fetishes, Blu tends to be more interested in the physicality of the animal form. This is demonstrated in his pieces produced around the architectural features of buildings e.g. his paintings of faces where tunnels or arches are edged with teeth to act as the characters' mouths. He appears fascinated by the physical realities of existence – birth, death, metamorphoses, evolution, growth, decay – the fleshy cycles of life.

Blu also produces works with social and political messages. His *Evolution of Man* piece, painted in London in 2007 showed the sequence of man's evolution from amoeba to dinosaur, to ape to gun-toting man shooting man, to dead man, to

BLU

skeleton and back to amoeba. His 2008 work on the exterior of Tate Modern in London depicted a man's head sliced open to reveal a series of rooms containing the horrors of war – dictators holding press conferences with skulls piled up behind them, missile factories and executions. In 2009 in Barcelona he painted a shark made up of Euro notes in reference to the current world financial crisis.

Blu paints from a crane for his large street pieces, blocking forms out in plain colour (often roller-painting these in white) and then outlining in black paint or charcoal, used to add detail.

He is notable as one of the most exciting artists working in street-art animation.

His piece *MUTO*, which was released on YouTube in 2008, is a brilliant, funny and disturbing stop motion animation painted on walls in Buenos Aires and Baden and filmed over a number of days. In it, Blu outlines, rubs out and repaints a variety of figures in white paint and charcoal to create a story unfolding along a wall.

Blu's *Letter A* animation, filmed in the Jonathan LeVine gallery, NYC is similarly compelling. This features a man sliced in half, his body disintegrating before he plugs his decapitated head into a wall socket and emerges as a robot from a mechanical chrysalis-like pod. It is as graphically physical a take on birth, death and rebirth as Blu's painted wall pieces.

LEFT: A Blu piece on the front of Tate Modern, Bankside, London. The work was commissioned as part of the gallery's 2008 *Street Art* exhibition.
BELOW: Blu shares wall space with Eltono in Madrid (taken 2008).

BO130

stencils, stickers, spray paint and Posca markers. He views all his work as "a work in progress. I love them all and I hate them all...I'll always be on a quest. From the exhibitions I do I keep a few pieces to follow the progressions."

Whilst he creates show-specific pieces he still gets out on the street, recently with Microbo, creating an amazing series of murals in disused churches in Puglia, Southern Italy. He thinks however that street art is taking a wrong direction "today kids fight for gallery space instead of city walls...that's bad...there's too much hype."

"I believe graffiti is a spontaneous expression of life" says Bo130. Recognisable by his 'space invader' logo, developed after 20 years of changing his tag every two weeks, BoBo (Robert) has painted collaboratively, with The London Police amongst many, and his pieces can often be found close to work by his wife, Microbo.

It all started when a 1985 trip to the USA from his native Milan at the age of 14 got Bo130 addicted to street art: "I remember those strange scribblings on walls which the book *Spray Can Art* then explained to me...at first it was the adrenaline rush that made me do it... then it became just the right thing to do! Art should be public, not elitist!"

Since those early beginnings, Bo130 has become a central figure in the street art world, and has exhibited in over 50 shows in Europe and the US. He is constantly experimenting with different techniques and materials, including paint,

LEFT: An early sticker seen on a lamppost in Shoreditch, London along with a number of Microbo germ stickers (taken 2003). **BELOW LEFT:** Paint-marker piece scrawled on a doorway in Barcelona's Raval district (taken 2005). **RIGHT:** A pair of faces and flying logos scrawled on this Barcelona door (taken 2005). **BELOW RIGHT:** 'Hello, My name is Bo130', but only if you recognise this as his very Space Invader-esque logo (East London, 2003).

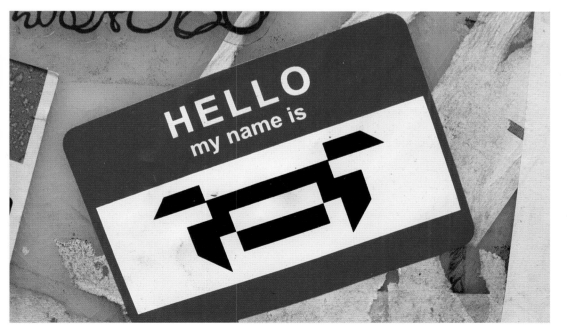

Bs.As. STENCIL

LEFT and BELOW LEFT: A collaboration between Bs.As. Stencil and Run Don't Walk at London's Cans Festival (2008).

The internationally-recognised stencil collective out of Buenos Aires, Bs.As. Stencil (named after the initials of their city B.A.) are Deborah, Nicolas and Gonzalo. They emerged at a time when Argentina was going through its worst crisis since the 1920s, characterised by a collapse in the currency, a banking collapse that saw savings wiped out, mass unemployment, and hunger amongst ordinary people on a shocking scale. The political mess that ensued saw, at one point, Argentina having five presidents in the space of a week. On the streets across the country, people responded with massive demonstrations. Horse-mounted riot police replied by shooting at unarmed crowds on the street and there were fatalities. It seemed as though the country was falling apart.

In this context, street art acquired an urgent political importance in Buenos Aires unlike anywhere else. Bs.As. Stencil were at the forefront of a move to reclaim the streets, to get youth politicised once more, to keep people informed, often through satirical visual imagery, about what was really going on. Stenciling became the means of voicing dissent. Bs.As. Stencil and other collectives such as Vomito Attack and Run Don't Walk, worked together with non-governmental neighbourhood assemblies and mass rally organisers; they would organise stencil 'parties', where the price of admission was food that could be donated to the needy.

Their art then involved direct, punchy graphics whose messages were clever and clear; according to Deborah "the ideas were simpler then. The stencils on the wall were like a common language everyone shared." Anti-government sentiment was fused with hatred of the Bush administration (the Argentine Peso had been linked to the US dollar) and hatred of the War on Iraq. A ship, representing Buenos Aires, was shown listing on the Rio Plata. The Argentine hero, General San Martin, was morphed into Elvis. A frequent text with the images read '*Se cayo el sistema*' (the system has crashed). Bush was shown with Mickey ears and the text 'Disney War'. Their most eloquent image of the time was of a speeding bus, with *inconsciente* (unconscious) written down its side.

It's hard to believe that, a few years on, with the worst of the crisis over, the debate that surrounds Bs.As. Stencil is whether they have sold out by transitioning to the gallery space. In 2004 they participated in the *ArteBa* show (called by critics 'a capitalist flea market'), with a piece showing five shopping carts filled with stencils. In 2006 they were the first group in Argentina to be singled out for a solo show: *Adentro* at the Centro Cultural Borges. The same year they were featured in the *Dicen Las Peredes* (The Walls Speak) show at the University of B.A. School of Architecture. Deborah said "it was a step forward for us artistically to focus on the difference between the street and the gallery." They have undertaken some work for ad agencies and expanded into merchandising. Their presence at the 2008 Cans Festival in London confirmed them as *the* ambassadors for Argentinian stencil art.

BTOY

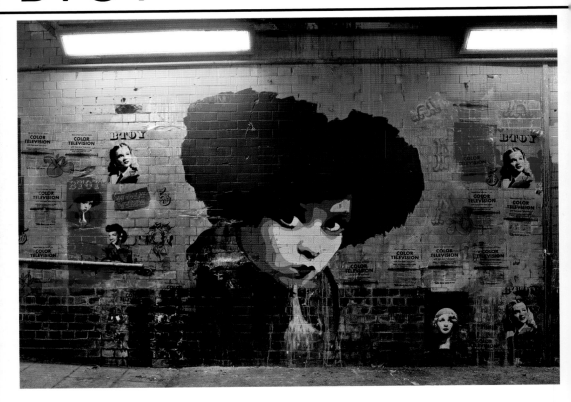

Btoy are a duo of ex-acid house warriors, Andrea Michaelsson and Ilia Mayer, both born in Barcelona in 1977 and 1975 respectively. They are famous for having had their work used in a Nissan Qashqai advertising campaign without permission (and therefore raising all sorts of issues about the 'ownership' of street art).

Ilia was an electronic musician and composer, who produced the Modular festival in 2005 in Barcelona. Andrea started as a graphic artist. Together on the streets of the Barrio Gótico they created a retro fantasy world of starlets, heroes and heroines. Ilia's art had a Nordic feel, featuring mysterious cartoon figures. Andrea used a typically Catalan muted pallet, with silkscreens of 1930s screen goddesses (Judy Garland, Louise Brooks and Greta Garbo amongst them) and aviatrixes with leather helmets and goggles, superimposed on late 1950s US Tele-Tone TV advertisements.

In 2008 Ilia and Andrea took part in Banksy's Cans Festival in London, showing Andrea's *Color Television* and Ilia's *Broken Crown* series.

In 2009 Btoy split, and Andrea and Ilia started creating and exhibiting on their own. Ilia's show at the Miscelania

ABOVE: Wall-sized piece from London's Cans Festival (2008). The large portrait in the centre is sprayed onto the wall. This piece is mainly the work of Andrea.
RIGHT: Detail of pasted-up stencil piece from the above Cans Festival wall.

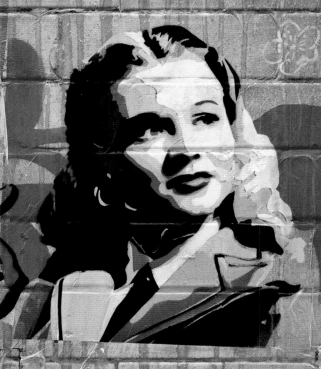

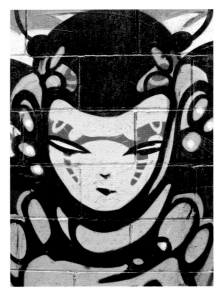

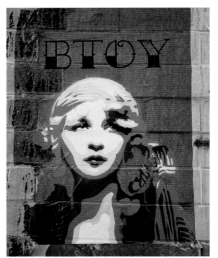

BTOY

glitch fm

LEFT (clockwise from top left): Close-up of a larger piece in Barcelona's Raval (taken 2005). // Ilia's large-scale contribution to London's Cans Festival (2008). // Another close-up of large piece in Barcelona's Raval (taken 2005). // Detail of Cans Festival pasted-up stencil (2008). // Geisha-themed stencil seen in Barcelona's Raval (taken 2005).
ABOVE: Another detail of the Barcelona Raval piece (taken 2005).

Gallery in Barcelona produced pieces exploring the relationship between the individual and nature, this time with Asiatic, almost Mongolian faces.

Andrea's recent work has stuck with her pallet of muted browns and ochres, and more colourful pieces in the *Six Degrees of Separation* series featuring the face of Liz Taylor in *Cleopatra,* and other female portraits in Cleopatra costume, all assertive and quietly amused.

Btoy have had considerable media coverage in Spain, the UK, Holland, Mexico and the US, where they are represented by L.A.'s famous

Charmichael Gallery. They have published two books of their work, and a series of prints for Pictures on Walls.

In the past they have taken part in live shows, in 2008 at Urban Painting in Milan, Galeria Oberta in Barcelona, No New Enemies in Brussels and Kosmopolite in Paris in addition to The Cans Festival.

They have also run extensive stencil workshops in Barcelona and Menorca. In Barcelona they designed Bar Lobo (2006) and created a mural for the Loring Art Bookshop (2008).

BUFF MONSTER

"I'm certainly not a graffiti artist, so please don't call me one. I've moved on" says Buff Monster. In 2001 Buff Monster started creating murals, hand-painted cans and paste-ups of his namesake character (which plays on the street term for graffiti getting removed or 'buffed') and put up thousands of posters over seven years of his "street art career". These days, Buff Monster says he goes out to stick up the occasional hand silk-screened poster "when I'm inspired to do so", but is more likely to be found working across other media – designing vinyl Buff Monster toys, creating canvases and installations for gallery shows, or painting Buff Monster designs on women's bikini-clad bodies.

Born in Hawaii and now based in Hollywood, CA, Buff Monster is 30 years old. He moved to L.A. in 1997 and studied Business Administration and Fine Art at USC, which perhaps partly explains the direction the Buff Monster brand has taken. Buff Monster names Andy Warhol, Takashi Murakami and Shepard Fairey as influences – not just for their work but because of the empires they have built, saying "Murakami, in terms of a business model to follow, makes more sense for me than Hello Kitty." Murakami works across the worlds of high art and 'low' art and his slick, streamlined surfaces and cartoon-like logos are plastered across mass produced (though high-end) products, from companies such as Louis Vuitton, as well as exhibited in galleries such as the Guggenheim, Bilbao.

The visual style of Buff Monster's work bears a resemblance to Murakami's: the Buff Monster logo permeates his work in a similar way to Murakami's Mr. DOB character, appearing on Buff Monster's on-street posters as an outlined logo; on canvases and prints in slickly applied, flat colours; situated within landscapes

BELOW LEFT: Rare Buff Monster 'in the wild' discovered in San Francisco's SoMA area. This was Buff Monster's first 'project' where he flattened cans and nailed them to telephone poles in San Francisco and L.A. (taken 2002).
BELOW: A pair of large-breasted Buff Monsters mixing with other artists' work on a wall in Barcelona's Raval (taken 2005).
RIGHT: Early production-run poster seen in downtown San Francisco (taken 2002).

THE
BUFF
MONSTER

BUFF MONSTER

Watson for the *Non Sequitur* series, he explains, "graffiti and Hollywood are about image, about making things bigger and prettier, like when I take a spray can that's rusted and ugly, and adorn it with beautiful pinks and metallics."

He has worked with adult entertainment magazine *Hustler* (art directing a shoot where he painted naked women) and America's leading adult film company Vivid, but says "the imagery of the Buff Monster character is very vague. I didn't want to dictate the interpretation. I like that the motifs can be interpreted as tits and cocks and cherries and ice cream, but kids can look at it and not be threatened by it."

LEFT: Just a Buff Monster face pasted onto this utility locker in Los Angeles (taken 2004). **BELOW:** A Buff Monster parachuting into a Shibuya, Tokyo side street in July 2004.

featuring squirting liquids, ice cream-like drips and cherries; appearing in a multitude of variations as collectable vinyl toy figures.

Buff Monster shows, such as 2007's *Happy Squirter*, have included installations that feature balloons printed with nipples and fountains that spray milky pink liquid "I feel I haven't achieved total environmental immersion yet...what I really wanted to do was take it to the next level, where everyone entering the gallery gets covered in a spraying pink fluid". Buff Monster says you could think of street art as "a candy coating on the city" and says he is influenced by the colour pink, ice cream, porn and heavy metal. While his pieces have appeared in Tokyo, New York and Europe, he is most associated with L.A.. In an interview with Marlin

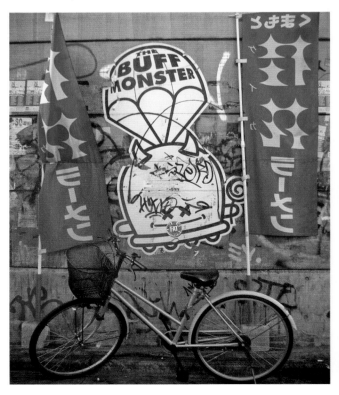

C215

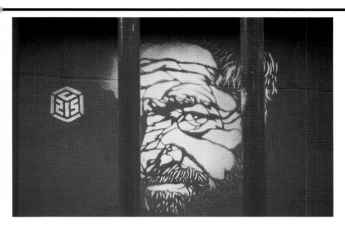

Berlin, Dakar, New Delhi, Casablanca, Tel Aviv, Jerusalem, L.A., Rome, Vienna, Newcastle and Brighton.

"I paint in the streets people really belonging to the streets: tramps, but also beggars, street orphans from the poorest countries" he says, and the faces of the children, workers and elderly vagrants who stare out of the surfaces he paints are poignant, partly because of his expert stencilling technique and partly because of the skill with which they are placed in such fitting locations. He aims to cut new stencils for each city in order to respond to its inhabitants, saying "context is the most important thing in street art. The only thing I never change is my logo. There should be a stencil for each situation."

ABOVE: This stencil is placed behind bars, giving it extra meaning (Shoreditch, London, 2008). **BELOW LEFT:** A girl looking over her shoulder on the side of The Griffin pub in East London (taken 2008). **BELOW RIGHT:** A look of hope in this stencil near London's Trafalgar Square (taken 2008).

C215 is a relative newcomer on the European Street art scene. He started painting life-sized Vespas in the streets of Orleans, France when he was 14 but has recently come to attention because of his intricately-cut stencils of faces. Originally from Paris, C215 have, since 2009, travelled internationally, creating new pieces in major cities including São Paulo, Brooklyn, Athens, Istanbul,

C215 has his own particular stencilling style. He cuts complex designs made up of small sections, which allow him

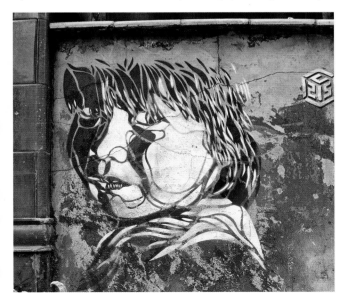

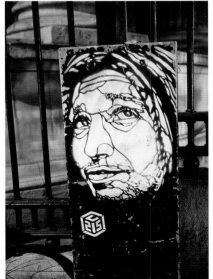

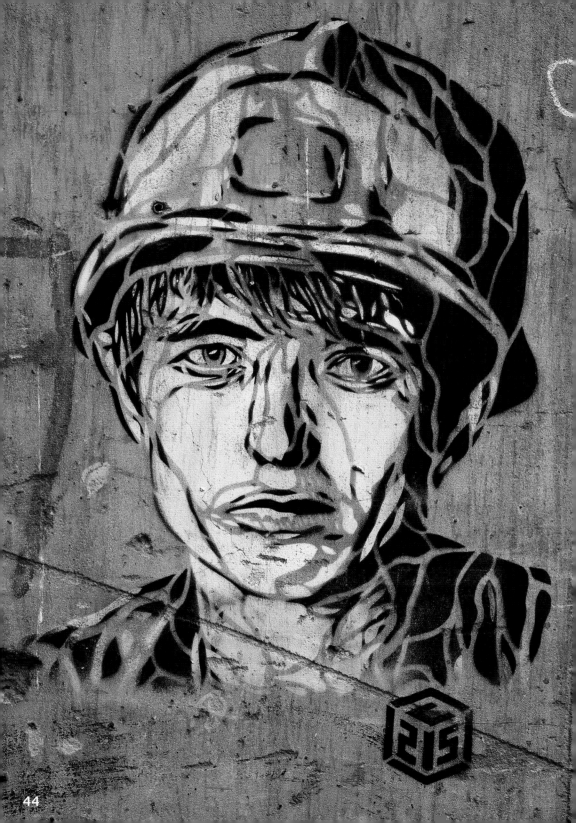

C215

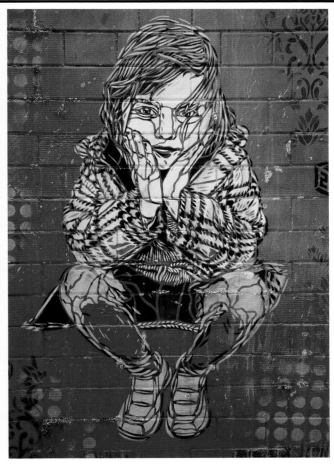

to build up a portrait in great detail, including wrinkles, the bristles on a moustache, individual strands of hair and folds of fabric. The use of contrasting layers of colour to create two-tone images gives the pieces depth. The fine lines are reminiscent of etching and allow C215 to put real expression and emotion into his portraits.

Coming across a C215 piece is like encountering an individual. On his choice of subject matter he explains that he is interested in capturing character, saying: "you can read a full life on a marked face. I guess that a lot of people never meet tramps because they don't pay attention to them. They have been fascinating me for a long time. You have to be very courageous to accept such a tough life."

He continues "I like to interact with locals, wherever I go, cutting ad hoc stencils for each trip...streets cannot be hit in the same way. I try to express with stencils something not so easy to get with such tools: to provide feeling and emotions to the people passing by."

LEFT: A miner at London's Cans Festival (2008). **ABOVE:** Great detailing on this intricate Cans Fest stencil piece (2008). **RIGHT:** A man peers out of a battered door into an East London alleyway (2008).

JAMES CAUTY

A dance and ambient house pioneer, agent provocateur, and one of those artists who doesn't see barriers between music, art, street art or politics, Jimmy Cauty has had a hugely influential impact on all four. His succinct artist's statement says it all: "James Cauty subverts and decodes our reality through iconoclastic strategies and re-ordered cultural histories. He also does art".

Born in Liverpool in 1956, Cauty was first an artist before moving into music with various bands, co-founding The Orb with Alex Paterson, and then the brilliant KLF with Bill Drummond. The dance and ambient albums *Chill Out* (arguably the first ever ambient house album) and *The White Room* were hugely influential and spawned a series of singles, which in 1991 made the KLF the best-selling singles outfit worldwide.

Cauty has always challenged the generally held signifiers of success, not with words, but actions. In 1992 the KLF, at the height of their powers, suddenly 'retired' and deleted their whole back catalogue, preventing any future commercial exploitation.

The pair re-emerged as the K Foundation, an entity which released music, but also created a prize of £40,000 for the worst artist of the year. In 1994 they caused a storm by burning £1 million in used banknotes on the remote Scottish island of Jura, and filming the event.

Turning from music to visual art, in 2003 Cauty founded the Blacksmoke Organisation, in part a response to the Bush/Blair invasion of Iraq. Taking one of the symbols of normality and trusted state authority – the stamp – he

BELOW and ABOVE RIGHT: Images of Aquarium L-13's 'storefront' in Farringdon showcasing Cauty/CNPD's *Operation Magic Kingdom* and STOT21stCPlanB's *London is Gone* (taken just before Cauty's 'strike' in 2007).

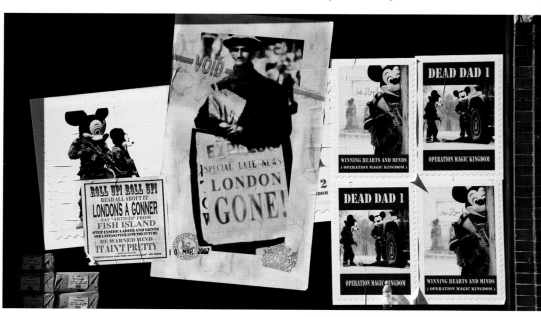

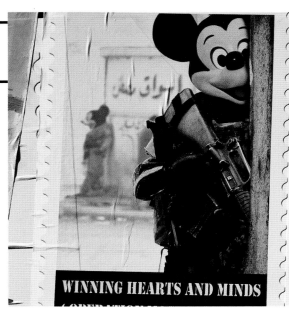
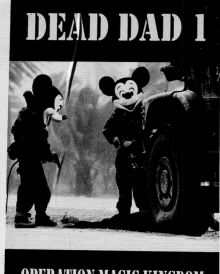

WINNING HEARTS AND MINDS

OPERATION MAGIC KINGDOM

produced a series of *Stamps of Mass Destruction*. The series was withdrawn when the UK Post Office threatened legal action. In 2005, working with the Aquarium L-13 Gallery in London, he created the Cautese Nátional Postal Disservice (CNPD), publishing real stamps, first day covers and limited edition prints. Subverting commercial norms again, he would organise "Great Stamp Culls", where the most popular images would be withdrawn.

The stamps were also produced as flyposters and billboards, and featured a series of images from the US invasion of Iraq, with superimposed Mickey Mouse heads. Labelled the *Operation Magic Kingdom* series, they carried satirical takes on Bush PR messages, such as "Winning Hearts and Minds".

One sequence entitled *Dead Dad* featured smiling Mickeys toting their guns in front of the figure of a dead Iraqi, perfectly capturing the sense of unreality of the real suffering caused by the war. Another set – *Bunny Bomber* – included Bugs

Bunny wearing a suicide bomber belt. Perhaps the funniest shows Bush in his fighter pilot's uniform – the image on the aircraft carrier when he declared that the war had been won – but in place of his helmet he is holding a Mickey Mouse mask.

In 2008 Cauty suddenly disbanded the CNPD – *The Mass Extinction Cull* – and offered its archive for sale on a portable LaCie hard drive at the random price of £2.8 million, with the promise that in 50 years it would be given to the nation. The *Operation Magic Kingdom* billboards and flyposters however, most of them posted in London's East End, remain some of the most powerful and memorable anti-war street art images.

It appears that for now Cauty has turned away from street art, although he recently produced some satirical billboards in Roy Lichtenstein style featuring the Queen and celebrities including Kate Moss and Nigella Lawson declaring how brilliant an artist Cauty really is.

CIVILIAN

LEFT and ABOVE:
Wide and detail view of Civilian's contribution to London's first Cans Festival in May 2008.

When Civilian (a.k.a. Tom Civil, a.k.a. Tom Sevil) moved to Melbourne in 2001 from his home town of Newcastle, 100 miles north of Sydney, he found "this beautiful mess of graffiti everywhere... it's where I started my more creative stencilling". Civilian had already experimented with political graffiti. In Melbourne he found a street art culture about to explode with creativity on the back of the new stencil form of the art, a youth that was anti the government of John Howard, and a crop of new artists who were competing to hit as many spots as possible.

From the start Civilian's stencils managed to surprise by being unexpected. There was a simple eloquence to his designs, as in the two soldiers carrying their wounded colleague, with the statement "All the arms we need". There is a real human quality to the work, a sense of the individual being bullied by larger forces. Civilian experienced this first hand in 2003, at the *Canterbury Empty Show*, when he was caught by police about to

create some anti-war pieces: "They had guns, they ripped up my stencils, they screamed at me 'How dare you criticise the army! That's my family! They defend our country!' It was quite scary".

There is a sentiment of idealism in Civilian's work, as revealed by his brilliant piece at the London Cans Festival in 2008, showing, amazingly, people just getting on. But his work can also have a real edge, as when the same charming stick figures appeared in a gallery piece with Marc de Jong in 2009 entitled *Subversive Resistance*, but this time wielding guns, corralling opposition.

Civilian is fully plugged into Melbourne's community and activism scenes. He is one half of radical publisher Breakdown Press, and works as a graphic designer for groups such as Seeds of Dissent, *The Big Issue*, Melbourne Indymedia and Stolenwealth Games. He also runs stencil-making workshops and gives frequent talks on the political importance of street art in a world run by globalised corporations.

CUT UP COLLECTIVE

Cut Up Collective disrupt and 'reorder' billboard advertisements and posters. They take the materials and commercial messages given to the public to consume by advertisers and rearrange these to create new images of social unrest, rebellion, and the city.

Their technique involves cutting posters down from billboards, slicing them into small sections, then rearranging and remounting the pieces to create new images. The effect is that of a billboard that has morphed and has a mind of its own, turning the advertisers own materials into a new, ungoverned expression of dissent.

The group also produce works using sheets of plywood, drilled with holes that, at a distance, (in a similar way to the cut up posters) form into crowd scenes but, up close, appear abstract and unclear.

The 'collective' part of the groups name reinforces the idea of social uprising, and a political movement. The images themselves do not have a direct political message, but instead show figures rallying, shouting, and riot scenes that hint at an uprising against consumer culture and a backlash against being constantly sold to. Recent work shows buildings being blown up and cityscapes that appear to be crumbling.

The work means the artists change from passive, silent consumers into active participants in the visual language of the streets, disrupting commercial ownership of public environments. This could be said to be true of much street art, but

BELOW: A billboard advertisement cut down, 'reordered' and replaced as part of Cut Up Collective's 2008 exhibition in the Seventeen gallery, Shoreditch, London.

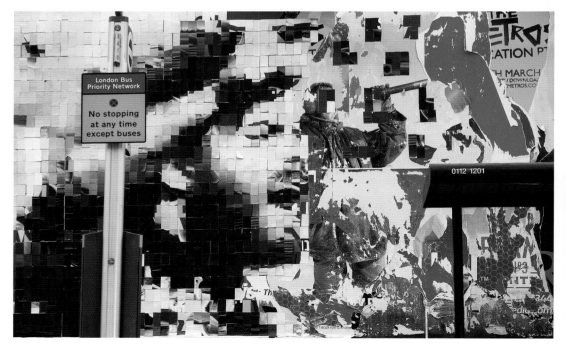

because the Cut Up Collective's work is placed in sites where we expect to see adverts, it is more directly challenging and anarchic.

The collective emerged on the street art scene in 2005. They are described by Seventeen gallery, who represent them, as a group of artists and musicians "linked by a shared desire to reorder the urban landscape through intervention and play."

As well as reworking established visual forms, the group's gallery work extends across different disciplines to include film and sound installation pieces.

For their 2008 exhibition *Grand Hotel Abyss* at the Seventeen Gallery, London, Cut Up Collective created two video installations, which involved deconstructing TV adverts frame by frame, then reassembling them to create nine new films.

D*FACE

London-based D*Face is a key figure in the international street art scene, not only for his work as an artist (he has been producing on-street pieces since the late 90s) but as the founder of East London's StolenSpace gallery, one of the city's leading contemporary art venues, specialising in exhibiting artists with a street art/graffiti background or connection, including Conor Harrington, Shepard Fairey, and D*Face himself.

A skateboarder in his teens, D*Face was drawn into graphic design by a desire to create skateboard graphics. After completing a degree in Illustration and Design, D*Face worked as a designer for an agency, but found that the lack of creativity involved made the job "mind-numbingly boring". It was while working —"slumped at my desk, head on arm pushing a pencil around a piece of paper and dreaming up ways to kill time" – that D*Face began to create the characters that are today a key feature of his art.

He turned these into stickers and posters, taught himself to screenprint and started sticking them up on the streets. "Anywhere I would go I would put up these stickers and just try to cover as much of London as I could. It kind of became a subversive intermission to all the shit that was around us. But I was never really aware of it. I was just putting my shit up wherever I went."

"At the time there was really only The Toasters and maybe Solo-One and Shepard Fairey who I was aware of that were doing anything." His focus was always getting work up, in order

to achieve a "creative release...for my enjoyment, a very selfish act," so he remembers being surprised when he realised the impact his work was having and that people knew who he was.

Achieving individual fame was not his intention; D*Face's aim was to put up work in order to get people to question their environment and the advertising around them. Eventually he quit his job and put his full attention into the art. He aims to "encourage people not just to 'see', but to look at what surrounds them and their lives", but he feels that now, "the more aware the public becomes of street art the less applicable [it] seems to be. Because it was like 'oh that's D*Face' or 'Shepard' or whoever, instead of: what is the meaning behind that."

The meaning behind D*Face's work increasingly relates to popular culture, consumption and advertising. He posts alternative public service announcements and the characters he creates have evolved from the classic D*Dog (seen left in various guises) to become political and satirical comments.

The *Her Royal Hideous* character, a skeleton version of HRH Queen Elizabeth II, with boney D*Dog ears, was pasted up around the time of the Queen's 80th birthday celebrations: "while everyone was planning various celebrations at the public's expense, I thought it would be fitting for me to paste my own 'tributes' all over town, for free". D*Face has drawn and printed onto the Queen's portrait on bank notes (adding the same boney ears, a shaven punk haircut and nose ring) then put them into circulation

D*FACE

LEFT: *Her Royal Hideous* falling apart after spending time on this wall near the Old Truman Brewery in East London (taken 2006). **BELOW:** Billboard wheatpaste in San Francisco (taken 2008).

for an "unsuspecting public to notice them in their change."

He has used images of cultural icons Che Guevara (in his *Cliché* piece, where a skeleton face replaces Guevara's in the mass-produced, commercialised image – "I love the idea of him coming back from the grave to kinda question what all of this consumerism is about") and Marilyn Monroe in his work. His 2008 gallery show *aPOPcalypse Now* was a piece of Pop Art/credit crunch culture jamming – with brightly coloured canvases and sculptures featuring superheroes and references to the recession in the US and UK economies.

D*Face is an extremely flexible

artist working across media from screenprinting, paste-ups and stickering to vinyl toys and sculpture. In September 2008 he illegally installed giant concrete spray cans across London from Hyde Park to Covent Garden and a huge metal D*Dog sculpture, created for the artist's 2006 first big exhibition, *Death and Glory*, can still be seen at the Old Truman Brewery, Brick Lane, London, close to the StolenSpace Gallery, which opened in 2005.

D*Face says his intention for the gallery was to have a space that is "artist run and led" and to "show artists that are unknown next to artists that are known and give everyone an equal chance to get their works seen."

DOLK

Almost as elusive as Banksy, to whom he has frequently been compared, Dolk Lundgren was born in Bergen, Norway in 1978. He began stencilling in 2003, without going the more usual route via tagging and graffiti, already aware of Banksy's techniques and the effects that could be achieved through visual wit. From the start Dolk wanted to reach a wide audience "I like it when many people understand what you are trying to convey...it's great to see children and old people laugh at my stencils." At other times Dolk has described his interests as "stencils, painting, exploring, sex" and "sex, sex and vandalism".

Dolk's images are highly thought-through and achieve that instant 'hit' that stays with you long after you've walked past. He frequently employs the devices of reversing assumed roles or debunking admired icons: so a girl steps out of a plastic doll costume; a gorilla is shown in a human costume; the Pope is shown in that famous Marilyn Monroe pose, trying to resist the air vent blowing his skirt above his head; Che Guevara is shown wearing a Che t-shirt in self-admiration; Prince Charles is painted in a Burger King hat.

It's all funny, sometimes a bit funny ha-ha, but occasionally Dolk achieves a more serious impact. His image *Zooicide* of a monkey pointing a banana at its head (the bananas he paints look as if they owe something to Warhol), which appeared in 2005, did feel like a comment on the idiocy of the invasion of Iraq, as did the image of a corporate figure, with a hand-grenade for a head, about to pull the pin. His images of childhood can be strangely moving, as

BELOW: Stencil piece from the Cans Festival, London (2008). **RIGHT (clockwise from top left):** Gorilla in a man suit stencil from the Cans Festival (2008). // Stencil piece in Lisbon (2007). // A boy seeing stars and Tweety-Pies (Lisbon, 2007). // One of Dolk's monkey pieces (Lisbon 2007).

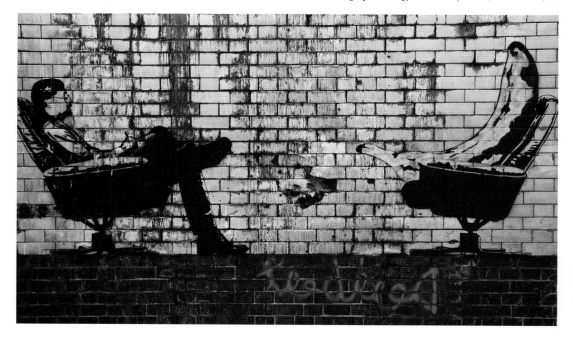

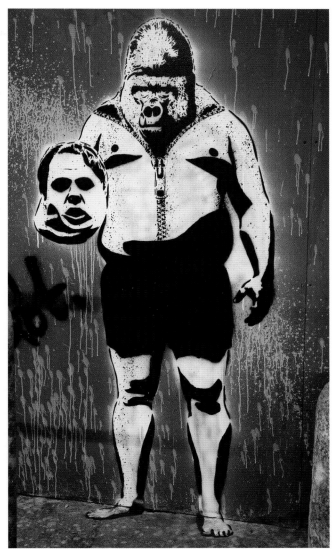

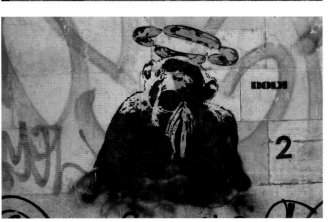

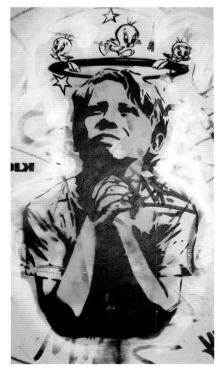

DOLK

in the girl with the teddy bear manacled to her hand, her head bowed. But then the fun returns: a boy praying intensely is shown to be dreaming of Tweety Pie, a girl in pigtails holding coloured paintbrushes is obviously going out to bomb the streets.

Dolk has been prolific. His work can be seen in Berlin, Lisbon, Barcelona, London and further afield in Melbourne. His prints tend to sell out instantly. 2008 saw him achieve something akin to establishment status in Norway, when he was invited, with the artist Pøbel, to paint a series of deserted wooden houses in the wild North of Norway, near Lofoten. The result was amazing, unusual and surprising, a testament to the energy that street art can bring to neighbourhoods abandoned by the rest of society. It also established Lofoten as an annual destination for street artists. In 2009 a further ten internationally recognised street artists were invited to add to Dolk and Pøbel's work.

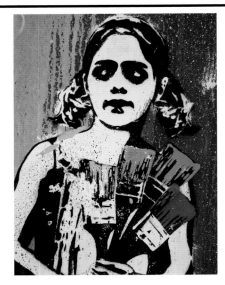

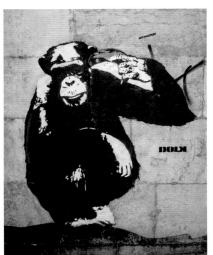

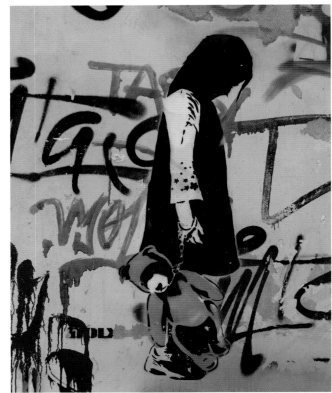

LEFT: Girl with paintbrushes from the Cans Fest 2008. **BELOW LEFT:** Dolk monkey in Lisbon (2007). **BELOW RIGHT:** Sad girl in Lisbon (2007). **RIGHT:** Dolk's *Pope meets Marilyn* stencil at London's first Cans Festival in 2008.

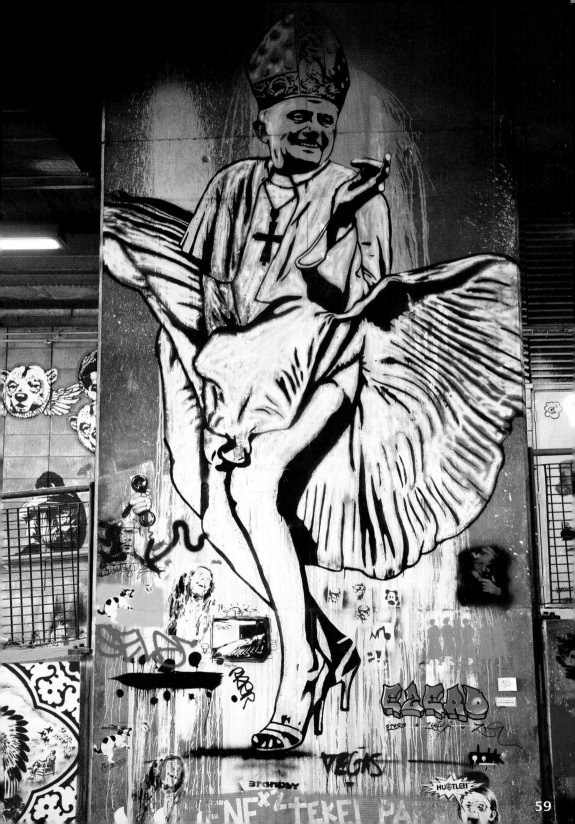

EELUS

Born in Wigan, northern England, Eelus started creating street art in Shoreditch, London, aged 22.

It was simply seeing the scene that drew him in: "I saw all these amazing pieces sprayed all over the city and was attracted to it instantly. Coming from a place where the only graffiti you could see was 'Kevin shagged Tracey here', it was amazing to see how the city had been turned into...a gallery open to all."

He knew he had to get into the scene, fascinated at the prospect that thousands of people would walk past his work and give some kind of response. He describes his inspiration as life, love and nature – and anything retro, from kitchen utensils to old-school cinema, as well as "visions and ideas of ages yet to come".

London, with its potential to be a dark and haunting place at times, "can lead to some interesting thoughts...if you have an imagination like mine".

The results are intriguing and full of disconcerting juxtapositions both in image and language: the kittenish Audrey Hepburn from *Breakfast at Tiffany's* having her eyes gouged out by a cute but vicious cat in *Tiffany for Breakfast*; the goth angel and demons he created for the Cans Festival in *The Good, The Bad and The Moon*, are completely ambiguous, making the viewer wonder which is which.

The disconcerting *Shat-at*, which has appeared in both stencil and sticker form, is an instantly memorable image of a robo dog inspired by *Star Wars* being restrained by a small child.

BELOW LEFT: A *Cheeky Cherub* stencil seen at London's 2008 Cans Festival. **BELOW:** *Tiffany for Breakfast* stencil at the Cans Festival (London, 2008). **RIGHT (clockwise from top):** An angel and a demon caught under a full moon in a tunnel under London's Waterloo Station (taken 2008, part of the Cans Festival). // A *Shat-at* sticker is walked over an Insa sticker on the back of this London street sign (taken 2008). // The *Shat-at* stencil seen on a wall in Shoreditch, London in 2003. **OVERLEAF:** This *Chewbarber* sticker was seen on a lamppost in Tokyo's Shibuya district one summer night in 2008.

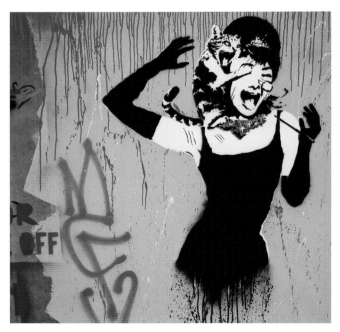

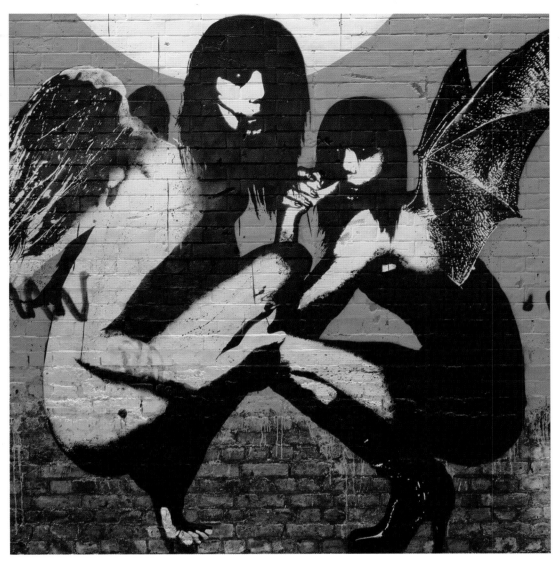

EELUS

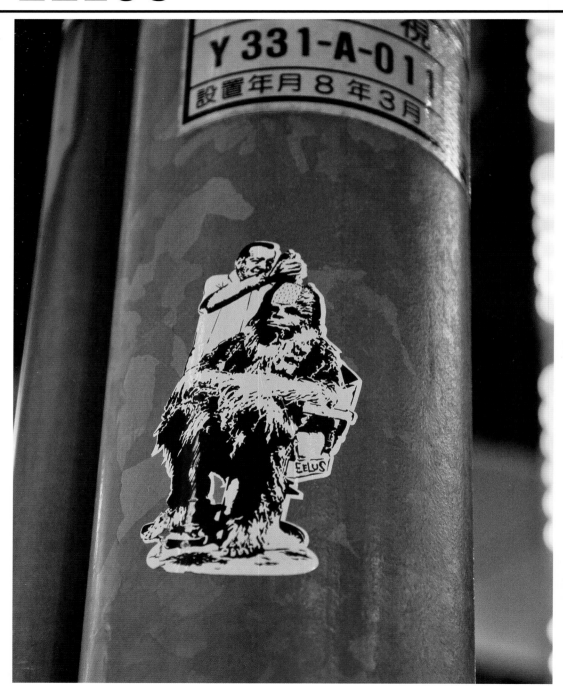

EINE

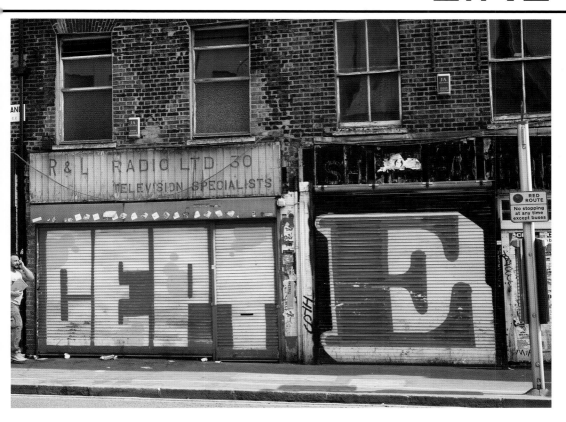

ABOVE: Eine and Cept adorn storefront shutters on Shoreditch's Kingsland Road in East London (taken 2007).

Ben Eine (a.k.a. Ben Flynn) is a London-based street artist who produces letter based work. He has been doing graffiti and street art in London for 20 years and in July 2009 began to break the US when his first solo show in L.A. opened at the Carmichael Gallery.

Now in his late 30s, Eine was arrested numerous times for doing graffiti when he was younger, and switched to street art when he decided that "the idea of going to prison at thirty-something for painting a train started to look like a bad career move." Of this transition, he says that "graffiti, for the most part, is done for fun and excitement and for the closed

world of other vandals...The things I paint now are done for an audience. I want people to see them and I want them to last."

His work is prolific in East London, where he has painted numerous shop shutters with letters. Eine explains how he started the project: "originally I was going to paint the shutter of an abandoned shop on Kingsland Road with Cept and he wrote 'CEPT' onto his shutter and I just wasn't into squeezing four letters on one shutter so I decided I was going to write E on one shutter and E on the next one and then I'd go back at a later date and do an I and an N.

EINE

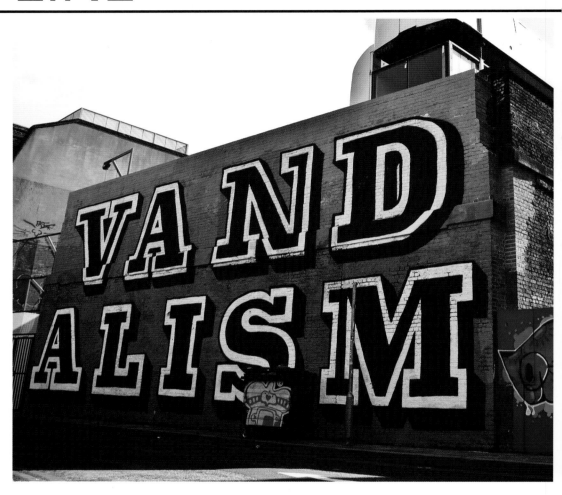

But when I actually looked at the photos of it I thought it looked quite good and probably raised more questions because I hadn't tagged it either, so I thought if I was actually just to write all the letters of the alphabet on shop shutters but not put my name on it people would think, 'What's going on here?' and assume it meant something and try to follow it. But it doesn't, it's just the letters of the alphabet."

The lettering in his 2007 murals *Vandalism* and *Scary* is restrained and neatly applied. Although the words are associated with graffiti by many people, the pieces have little in common with expected images of graffiti, and yet the pieces were illegally applied, without the permission of the walls' owners. The pieces could be said to improve their surroundings, and raise questions about street art's ability to improve run down areas. The shop shutter letters (often

ABOVE: Piece in East London coinciding with his *Vandal* show in 2007. **RIGHT (clockwise from top left):** Letters on the 333 Club, Old Street, London (2008). // A 2007 piece next to London's Kemistry Gallery, host of the *Vandal* show. // One of many letters painted onto East London shop front shutters (taken 2007).

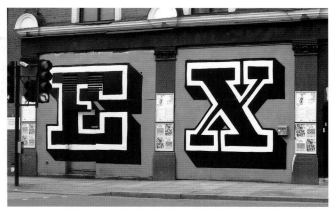

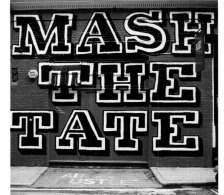

EINE

painted with the owner's permission – "the thing is, a lot of these shutters were covered in tags anyway. I generally don't approach people with a brand new clean shutter because they're more likely to say no") were featured in a questionnaire Tower Hamlets council sent round to residents (as featured on the Wooster Collective website in 2007) asking how they felt about graffiti/street art, in order to try and decide if any work should be preserved rather than painted over.

Eine says that with this work "the response from the public has been overwhelmingly positive. I think one of the reasons for this is because they don't think that it is graffiti". The shop owners agree "down Broadway Market every time I painted one someone would come out and ask me to paint theirs."

Whether working on shutters, walls, canvas or screenprints, Eine keeps his focus on typography. As well as the 'shutter' typeface, he has created fonts such as neon, elton, circus, and wendy, and sells prints of these through influential street art print merchant Pictures On Walls (POW), who commission limited edition work by artists including Banksy, Dolk, Eelus, Blue, Btoy, David Shrigley, Modern Toss and Sickboy. In an article he wrote for *Swindle* magazine's London issue, Eine explains that he worked in the city for twelve years, for Lloyds of London, but after giving up this "proper job" worked as a screenprinter for POW for five years. He said at the time "I have an interesting job: I'm a screenprinter, I print all the posters, and I sell my art and I paint all the shutters for nothing. Yeah, it's not a bad little life."

BELOW: This piece went up around the time of Eine's *Vandal* show. This underpass (the location of the entrance to East London's Cargo) was also home to a series of Banksy pieces in the early 2000s (taken 2007). **RIGHT:** Elbow-Toe paste-up seen in Shoreditch, London (2008). **BELOW RIGHT:** A simple Elbow Toe paste-up in East London (taken 2007).

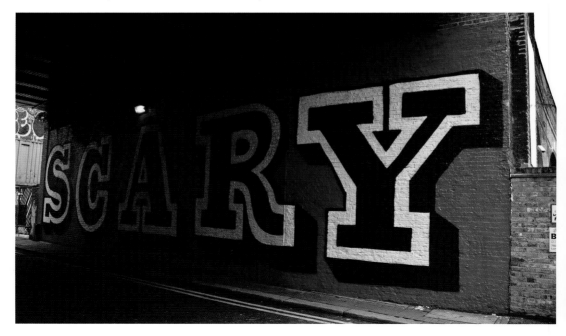

ELBOW TOE

"Elbow Toe Takes His Pills." "Elbow Toe Rips You Off." "Elbow Toe is Boring." At least one of the above statements is not true. Elbow Toe arrived in 2004 on the streets of New York (and more recently, London) with a barrage of diverse and vibrant street art work, ranging from lino cut prints and charcoal drawn paste-ups, images and text hand-written directly onto walls, and self-referencing statements, such as those listed above, set in plain headline-style type, printed out and pasted on newspaper boxes and walls.

Elbow Toe decided to move his work onto the streets after seeing photos a friend had taken of a Swoon piece in Red Hook "I felt, wow, OK, I don't have to be stupid with my characters, I can actually bring my fine art to the streets...I could put crafted, drawn work out, that it didn't have to be this big graphic thing, necessarily." He was attracted by the immediacy of the process "You could put it out there and actually have it appreciated, and not just put the canvas in a storage space, and hope maybe for a gallery show." His woodcut prints

ELBOW-TOE TAKES HIS PILLS

NATTY

ELBOW TOE

of twisted figures are made by cutting into plywood, which is then inked and pressed onto Kraft paper – "for a good forty minutes a print, I want to get a rich black" – before being cut out.

He sometimes draws or paints on top of the Expressionist-style images. Many are portraits of his family; Elbow Toe draws these from photographs of his subjects taken from multiple angles.

Elbow Toe is enjoying exploring street art's potential; "maybe it's a bad habit, but I tend not to stick in one way of working for too long. I get really curious." As well as Swoon, he admires the work of Judith Supine, Gore B and

Os Gêmeos. "It's interesting to see how figurative work has legitimacy in the street art realm that it doesn't necessarily have in gallery spaces" as well as REVS – who part inspired his self-referencing poster campaign.

His self-admittedly 'silly' name was coined in honour of Neck Face. He sometimes regrets this choice, as he explained in an interview with Michael Natale of Gamma Blog: "I got some drinks with a friend at the Rodeo Bar, and had written my name in the bathroom. And someone wrote beneath it, 'Elbow Toe – Good Art – Worst Name Ever!' Elbow Toe, you can't be all cool like 'I'm REVS' or something."

ELTONO

Born in 1975 in Cergy-Pontoise outside Paris, Eltono started producing graffiti in 1989, bombing the railway line from his native suburb to Paris with the GAP crew. After studying plastic arts at St. Denis, he moved to the Complutense University in Madrid in 1999 and stayed in the city.

Initially he used the name Otone – Italian for Autumn. In Madrid he switched to Tono (Spanish for 'tone', be it colour or audio), then added 'El'. As graffiti, particularly in Madrid, became saturated, many street artists started using one symbol to make their work recognisable. In this vein Eltono developed a tuning fork device.

His early technique with the tuning fork used spraycans and 3-D effects. By 2000 he rejected this as a solution and started working with masking tape and acrylics. With this new technique came an abstraction of the tuning fork, changing shape and colour wherever it appeared, more often than not on dilapidated structures where he could work uninterrupted. Soon Eltono's abstracted shapes began to be seen all over Madrid.

Eltono, however, is more concerned with location than blanket and very public coverage: "by being in obscure locations I can add privacy to an encounter with my work, and so I increase the penetration within each of them."

This concern with the subtle experience is reflected in other aspects of his art. Fascinated by basic commercial communication, he has subverted the posters and stickers posted by

BELOW: Eltono and Nuria Mora in Malasaña, Madrid (taken 2008). **RIGHT (clockwise from top left):** Eltono emerging from rubble in Zaragoza, Spain (taken 2008). // An Eltono piece in Tirso de Molina, Madrid (taken 2006). // Doctor Cortezo, Madrid (taken 2006). // Another Eltono piece from Madrid (2006). // Eltono and ants in Lavapies, Madrid (2006).

71

ELTONO

locksmiths and domestic helpers (both ubiquitous in Madrid), but so subtly that you have to look carefully to distinguish them from the originals.

Since 2002 Eltono's work and that of his partner Nuria Mora has been shown by the Vacio 9 gallery in Madrid. Rather than just produce works for the gallery, Eltono has sought to negotiate and comment on the relationship between the art world and the street. The pieces created for his gallery shows are based on a negative of an illegal piece of art in that same city. Each piece of gallery art carries a photo of the street version, a clever comment on the art market's need to create value and 'authenticity'. It also marks Eltono's desire to stay close to the edge, to his artistic roots.

Recently Eltono's work has turned towards urban interventionism. In New York his PLAF project used driftwood from the East River attached to old pier supports to create a living, kinetic sculpture.

He has also spent time painting in Monterrey, Mexico, with his friend Fidencio, who creates work based on the folk icon Fidencio Constantino.

BELOW LEFT: Eltono in Madrid (taken 2007). **BELOW:** Eltono with Fidencio Constantino in Monterrey, Mexico (taken 2007). **RIGHT:** Eltono in Madrid (taken 2009).

ESOW

A pro skater who also loves bikes, Esow was born in Tokyo in 1972. Coming across graffiti for the first time aged 16, he was instantly hooked and developed his signature style combining traditional Japanese art techniques and graffiti. Affiliated with the WOM (Word of Mouth) crew, Esow has painted with some of the other top writers on the Tokyo scene, including Kami, Depas, Kress and Casper.

Amongst his peers Esow is recognised above all for his character work. There is something about the way he draws a line that captures the essence of his subjects, from old men, to young punks in jeans, in a few simple strokes. He works mostly in black and white and with a muted palette of ochres and browns (There are exceptions, and some of the mural work with Kami is highly-coloured). Beginning with a white background, he paints his lines painstakingly in freehand and with a brush.

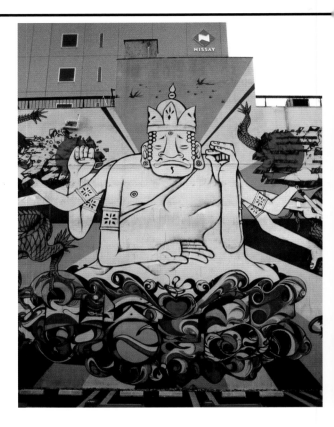

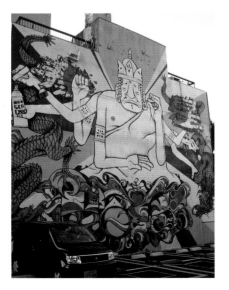

Esow's work can be seen on the streets and on the walls of playgrounds in Tokyo and Yokohama. He has also painted at the notorious Kanagawa abandoned hospital, which has the reputation of being 'the most haunted place in Japan'.

Whilst he keeps an ultra-low profile, rarely giving interviews or commenting on his work, Esow has long had good contacts on the US West Coast skate scene.

In 2009 he created some great skate deck designs in silver, black and gold for Ken Uyehara's FTC store in Haight Street, San Francisco.

ABOVE and LEFT: Esow piece with Kress, Dice and Depas in Ibaraki, Japan (taken 2006). **RIGHT:** Esow and Kami in Ueno, Japan (taken 2008).

ETHOS

LEFT (clockwise from top): Ethos on a graffiti wall in Londrina, Brazil (taken 2006). // Another Ethos piece from Londrina, Brazil in 2006. // An Ethos figure blows bubbles in Londrina (taken 2006). **BELOW:** A twisted Ethos figure in Londrina, Brazil (taken 2006).

One of the towering figures of the São Paulo street art scene, Claudio Ethos was born in 1982 and started putting work up on the streets aged 15. His work is, in essence, vast portraiture, picking intense characters from this teeming metropolis of 21.5 million souls, and painting them on hoardings, sides of buildings and unexpected corners, usually with a very sympathetic and emotive take on their very human struggles and desires.

In keeping with many of the *grafiteiros* of Brazil, Ethos paints freehand, usually directly from a small highly-detailed image that he has executed in ballpoint. Laying a ground of white emulsion with a small roller, he then completes the image in enormous detail, but on a huge scale, with spray can, usually just using monochrome effects for areas of light and shade. Whilst his images are figurative, and his portraits recognisably those of individuals, he often strays into surrealist territory, painting tortured faces emerging from tree-root-like bodies, or fish-heads emerging from the naked bodies of girls. The range is considerable, with echoes of Francis Bacon in one portrait, or of Max Ernst in the next.

Admired by his peers, he's had huge success on the gallery circuit as well as on the street. In 2008 he showed at FAME festival, followed by several solo shows, including Studiocromie Gallery, Puglia, Italy (2008), San Francisco's 111 Minna Gallery (2008) and at the Christopher Henry Gallery in NYC (2009).

EVOL

Evol paints electricity boxes and urban furniture, stencilling and pasting on tiny windows and balconies to transform functional surfaces into mini tower blocks that reflect the mundane architecture of the city back on itself: a clever, original and surprisingly effective visual trick. This makes us look again at what surrounds us – the battered or graffitied surfaces he selects make perfect and convincing backgrounds for the amazing mini-buildings he creates within the city.

Based in Berlin, Evol focuses on the tower blocks that dominate the city, built by the government after WWII in response to a shortage of housing, and the need to provide affordable living spaces for workers. He is skilled at imitating the graphic, repetitive lines of the buildings, but Evol also likes the subject because the blocks are "perfect reminders of human error".

"These housing projects promised to make the socialist dream come true by offering a higher standard of living that everyone could afford. But, beside the fact that the government ran out of money, this dream has turned into a (dys)functional nightmare."

In his off-street work, Evol stencils details of city life onto cardboard, as it is "full of imprints and marks of usage. A cheap material that no one cares about and which changes its value when painted on."

He has created large scale installation works, including a corridor at Berlin's now-closed Flamingo Beach Lotel, which he made into a mini street scene. The play with scale meant that those passing through could wander through Evol's city scene like giants.

BELOW LEFT: This stencilled Evol paste-up of a tower block in Cologne (April 2006) was bombed by the artists of UNDENK'S SECRET SHOWROOM (Deer Bln, D-Cide, Pisa73 and Undenk).
BELOW: A bin is turned into a mini building via a stencilled Evol paste-up (Cologne, April 2006).

ABOVE: A stencilled piece in Friedrichshain, Berlin (2008). **RIGHT:** A stencilled paste-up in Cologne (April 2006).

FAILE

LEFT: Detail of a doorway stencilled for the 1st Cans Festival in 2008. A number of Faile's classic images are integrated into the overall piece, including their reference to the 1986 Challenger space shuttle accident. **BELOW:** A pair of *Bunny Girl* posters wheatpasted in Shoreditch, London (taken 2003). **BELOW RIGHT:** *10 ways...* stencil on a wall near the Meguro Canal in Nakameguro, Tokyo (taken 2005).

Faile is a collective founded by Patrick McNeil, Patrick Miller and Aiko Nakagawa (from Canada, the USA and Japan, respectively). Based in Brooklyn, New York, they started working together in 2000.

McNeil and Miller met in high school in Arizona, and started collaborating by "passing sketchbooks back and forth when we were 14 years old."

Parting ways to study at different colleges (Miller at art school in Minneapolis and McNeil in England and then NYC), McNeil met Nakagawa when working at a club in the Meatpacking District and they began to take photographs together of the street art springing up in New York in the early noughties.

McNeil and Miller started travelling between Minneapolis and New York, collaborating on screen prints in the print labs at their art colleges and then the three began to produce work together, covering major street art destinations such as London, Tokyo,

Barcelona and Berlin and, of course, New York, in wheatpastes, and later, collaboratively-produced stencils.

In 2006, Aiko left the group to concentrate on her own work, while Miller and McNeil continued to work together as Faile.

The group originally began working together under the name Alife, which was taken from a sketchbook piece by Patrick Miller. Quoted in an interview with Manuel Bello on fecalface.com Patrick McNeil explains "After a month or so of putting the work up we realised there was a store in the Lower East Side that was using this name. We knew we had to change the name."

"One night while putting work up, we were arrested. Given some time to ponder our dilemma, Faile was born. By rearranging the letters we found Faile. We really liked the idea of it, that you could Faile to succeed. That there was this growth process where you could create the most from what you were given and move forward from there."

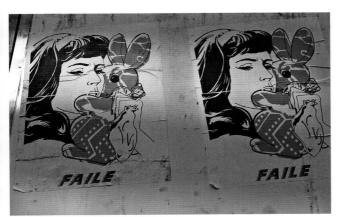

FAILE

Faile are now an established name on the street art scene, producing gallery shows, selling prints through their website and continuing to create on-street work. Recent exhibitions have included wooden sculpture pieces, including stacked boxes and circular posts, printed with Faile designs, adding a 3-D dimension to the work. They produced a large scale piece for Tate Modern's *Street Art* show in summer 2008, which was pasted on the façade of the gallery alongside works by JR, Os Gêmeos and Blu.

Faile are graphic artists who mix found imagery with their own visuals, often working in a monochrome palette. In an interview with *Ion Magazine*, Patrick McNeil said that the imagery in the work "comes from anywhere and anything. It could be from a fish and chips box graphic. Everything is mixed and mashed. Some of it is drawn by us but it is a host of appropriated imagery all collaged and fucked up."

Familiar choices are vintage graphics, pulp comic headlines, advertisements, low-fi illustrations and the female nude.

Images are juxtaposed with any direct meaning obscured.

McNeil explained to *Swindle* magazine that when they started out "we were seeing so much that [was] trying to make a point politically...We were trying to find something...that conveyed emotion – that captured this moment where there was something more happening – that left the viewer room for their own interpretation. Something that played into your heart and let you relate on a more visceral level."

BELOW LEFT: Detail from Cans Fest piece (2008). **BELOW:** A quadruple installation of *Faile Dogs* pasted in a Shoreditch, London alley (taken 2003). **RIGHT (clockwise from top left):** A *Bunny Boy* stencil on wall in Barcelona's Ciutat Vella (taken 2005). // Another detail from the Cans Fest piece (2008). // Paste-up in Berlin (taken 2007). // Hand-painted name in London's Old Street (taken 2006).

SHEPARD FAIREY

"I want to reach people through as many different platforms as possible. Street art is a bureaucracy-free way of reaching people, but t-shirts, stickers, commercial jobs, the internet – there are so many different ways that I use to put my work in front of people" declared Shepard Fairey, in 2009, in a pretty fair summation of a stellar career which has thus far encompassed everything from street art to fine art, from working for mainstream corporations such as Saks to receiving a personal letter of thanks from Barack Obama for supporting his candidacy for President. If artistic success was measured solely in terms of a presence in some of the world's major collections, Fairey might well come near the top of any list of contemporary artists; MOMA New York, The Smithsonian, The L.A. County Museum of Art, The US National Portrait Gallery and the V&A in London have all acquired Faireys for their permanent collections.

Born in 1970 in Charleston, South Carolina, Fairey developed his obsession with art aged 14, and first used his design abilities on skateboards and t-shirts. He went to the Rhode Island School of Design (RISD) and it was in 1989, during his first year, that he developed his *Andre the Giant has a Posse* sticker campaign. Melding his knowledge of the hip hop and skater community – who would appreciate a rebellious in-joke – with a shrewd hunch that the timing was right to create a sub-cultural exercise in media manipulation, he and several fellow students began propagating thousands of stickers all over Providence, Rhode Island, and

then other cities on the East Coast. The phenomenon took off beyond any initial expectations and acquired sufficient traction that Titan Sports, owners of the Andre the Giant trademark, threatened legal action. Fairey, in a manifesto of 1990, declared that Andre the Giant had been an experiment in phenomenology, but what he really proved was the power of the street to create a global, viral artistic experience, which could feed off itself. To further illustrate the point, in 1995 Helen Stickler created a documentary short about the campaign, which screened worldwide and was a hit at the 1997 Sundance Film Festival, further propagating the phenomenon.

For Fairey, the Titan lawsuit, which came in 1998, was to provide a major artistic breakthrough. He decided to morph the wrestler's face into a new, graphically more sophisticated and easily-stencilled design, most often now combined with the word OBEY. Whilst the source of

BELOW: A small Andre printing press stencil adorns a wall among trendy boutiques in Tokyo's Daikanayama district (taken 2005). **RIGHT (clockwise from top):** One unique *Obama* poster was created especially for San Francisco's 2008 Folsom Street Festival. It features Obama in leather, sporting the fetish event's logo, and appropriately using the OBEY tagline. // A classic Andre poster found in San Francisco. These posters were put up by the artist while in town for his 2008 *Duality of Humanity* solo show. // These large columns under I-280 in downtown San Francisco used to attract many artists before the city cleaned up the area. A set of *Obey* posters face one direction while a set of Andre posters face the other (taken 2001).

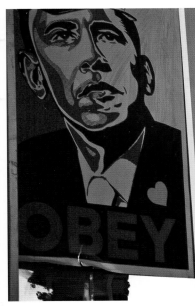
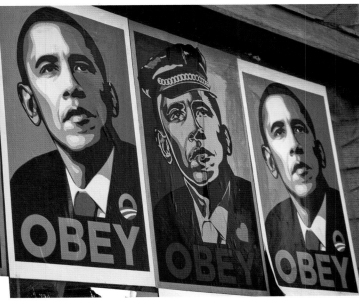
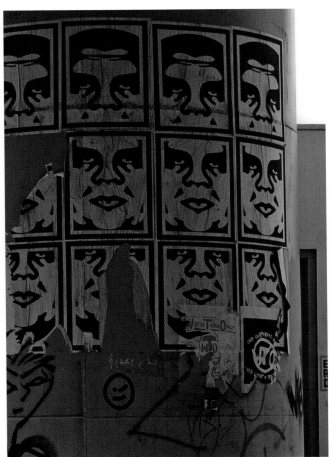

SHEPARD FAIREY

the *Obey* idea may have been the John Carpenter cult movie *They Live*, this had nothing to do with its success. There was something about the face and the sense of creeping authoritarianism that was perfect for the time. When the stickers started appearing all over New York it seemed almost an ironic reference to Rudy Giuliani's zero tolerance, clean-up the streets campaign. It was also the time of an increasingly shrill character developing in the Republican Party, that was a precursor to the eventual election of George Bush.

Fairey's instinct was also right on song, again. *Obey* was at the vanguard of stencilled street art which carried no message but its own slightly disturbing presence – Fairey was fond of quoting Marshall McLuhan's "The Medium is The Message" and this was a perfect evocation of it. Soon *Obey* stickers

could be found in most major US cities and beyond. Other artists had taken to copying the stencil and spraying it themselves, willing participants in a visual phenomenon. The campaign was already drawing comparisons with Marcel Duchamp for its ironic eloquence.

Whilst on one level conquering the street, Fairey was also growing a commercial design business, very aware that his notoriety would be attractive to a number of commercial brands. With Dave Kinsey and Phillip DeWolff he founded a guerilla marketing design studio, BLK/MRKT Inc. whose clients included Netscape, Pepsi and Hasbro. He has been criticised for this, for appropriating the freedom of the streets for those who buy the streets for their own purposes, denying others that freedom. Fairey's defence is that designers have to make money. But

BELOW: A pair of *Obey* posters hiding in a doorway on Toronto's Queen Street West (taken 2007). **RIGHT:** Another classic poster put up by the artist while in San Francisco for his 2008 *Duality of Humanity* solo show.

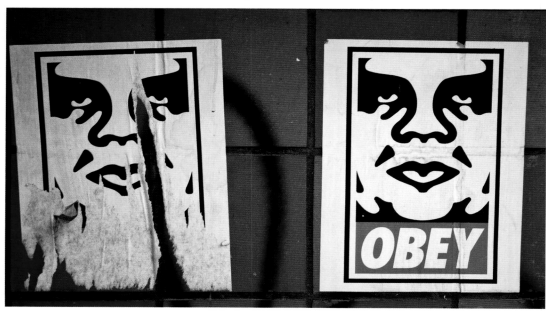

SHEPARD FAIREY

LEFT: A different take on *Obey Obama*. A classic Andre poster shares this San Francisco alley with an Obama/Lincoln mash-up by Ron English (taken 2008).
BELOW: This Andre sticker doesn't seem out of place on this sign in front of the San Francisco MoMA (taken 2003).

there is little question that he has been brilliant at it. The fact is that Fairey wanted to be ubiquitous, not street-exclusive: he likes his populism, and in any case from day one he was producing and selling t-shirts and skate stickers. *Obey* simply followed this trend.

He was also incredibly hard-working and prolific. Having conceived of *Obey*, he started pushing the idea

in many directions. An interest in authoritarianism led him to take authoritarian art from the usual suspect regimes as inspiration: China, the USSR, Cuba and Vietnam amongst them. The retro quality, at a time when everyone else was obsessing about .com, of images of smoking factory chimneys as symbols of national prowess, or heroic female soldiers fighting for The Revolution appealed to him, as did aspects of mannered constructivist typography. Fairey had hit a rich vein, and he exploited it fully. Where *Obey* had had no specific message, the advent of Bush in the White House, 9/11, and the use of that as an excuse to invade Iraq, suddenly gave Fairey's art a purpose and portentous meaning.

Bush's was a regime that did seem to want everyone to fall into line, not to question, but to blindingly obey as it reduced US civil liberties. Fairey at this point became openly political. In 2004 he joined the art collective Post Gen with anti-war artists Robbie Conal and Mear One. He created a series of posters for the *Be The Revolution* street art campaign, aimed at exposing the hypocrisy and limiting of human rights by the Bush administration.

2004 was also the year when Bush first appeared, satirically, in his posters, in *Hug Bombs and Drop Babies*, and when Fairey produced *More Militerry Less Skools* , his spray-can figure *Mr Spray Says Make Art Not War*, and the brilliant *Greetings From Iraq*. One of his iconographic images, the gas-masked figure, also made its first appearance in 2004. Simultaneously, an increasing

PUSH BUTTON FOR

R62DL5

TRAFFIC SIGNAL

89

90

SHEPARD FAIREY

LEFT: This large collage of posters was done on-site outside the San Francisco gallery hosting Fairey's 2008 *Duality of Humanity* solo exhibition.
BELOW: A *Disobey* sticker strategically placed on a crosswalk signpost on 3rd St in Los Angeles' Fairfax district (taken 2003).

interest in decoration and gravure led him to develop the Obey logo into an intricately patterned star that he could in turn insert into tiled patterns. As ever original, Fairey was combining a symbol of authoritarian oppression with the sort of decorative floral designs for floor tiles one might find in a Victorian Owen Jones pattern book. The occasional Islamic overtones of some of the designs were no accident.

Throughout this period Fairey also worked as a fine artist, defying any attempts to pigeonhole him, creating pieces with similar iconography and visual themes as his print work and street art stickers. He created immensely detailed work on wood, metal and rubylith (masking film). He also created large stencilled and collaged gallery pieces, and installations. Fairey's work appeared in a couple of books *Supply and Demand: The Art of Shepard Fairey* (2006) and *Philosophy of Obey: The Formative Years* (2008). His first one-man show opened at the Jonathan LeVine Gallery in New York in 2007.

It seemed at times that Fairey was himself going for world domination. As if this wasn't success enough, the poster he produced during the 2008 US presidential race – *HOPE* – proved one of the abiding images of the election. Fairey funded the distribution of 300,000 stickers and 500,000 posters himself, keeping a little distance between his supposedly illegal activities and the Obama campaign team. The word 'Obey' was less in evidence. Obama wrote to thank him: "your images have a profound effect on people, whether seen in a gallery or on a stop sign. I am privileged to be a part of your artwork and proud to have your support."

The *New Yorker* described *HOPE* as "the most efficacious political illustration since 'Uncle Sam Wants You'." In 2009 Fairey crowned these achievements with a retrospective of his work at the Institute of Contemporary Art in Boston. True to form, the Boston PD arrested him for some outstanding graffiti violations on his way to the premiere.

CONOR HARRINGTON

LEFT: A large scale wall piece opposite the Old Truman Brewery, near Brick Lane, London (taken 2008).

Conor Harrington saw his first piece of graffiti when he was twelve in, of all places, *National Geographic Magazine*: "there was no graffiti scene in Cork." He did his first piece aged 14, and then discovered fine art at school at around the age of 15. From that point on he knew he wanted to be an artist – without yet having an idea of what sort of artist – and went to art school in Limerick.

For years Conor was torn between the worlds of graffiti and fine art, keeping the two separate. He plugged into the Irish graffiti set in Dublin and Drogheda, did some stuff in New York and Amsterdam and, at a time when he was beginning to tire of the graffiti scene, hit upon the solution: to combine the two. This was the point where his signature style, and originality, emerged.

Conor was already too much into art to reject the art-historical canon and to dismiss the whole of the art market. His images now derive their energy from taking one of the most traditional, propagandist representations of paintings in oil – the 19th Century portrait of the military hero – and disrupting it, painting peeling paste-up effects and abstracted strips of colour crashing through the picture. In an English context this gives his images a particular energy, suggestive of the trauma, trashed dreams and guilt of Britain's imperialist past.

His heroes look almost ephemeral, like memories from a distant dream. But there remains something wistful about them – Conor is too subtle and skilled to make his images simple propaganda in return; his Victorian heroes have a quiet,

stoical, masculine dignity; there is almost a sense of loss that this valuing of blind courage and dignity is no more.

Just as Conor has found a way of combining historical genre painting and graffiti, so he draws little distinction between his street pieces and his canvas works for his gallery, Lazarides.

They are both similarly beautifully worked and the concerns are similar; according to Conor the male figures in his works are "referring to the masculinity of urban culture". The context shifts one's perception of the painting however: on the street, the highly figurative element of the work is shocking; in the gallery pieces it is the graffiti elements that surprise.

Conor's techniques also combine the two worlds. The outside pieces are on a large scale, but then his canvases are usually also around 2 metres x 2 metres. For the canvases he uses oil and aerosol. For some outside pieces he has also used charcoal, achieving a level of detail and precision that again feels dissonant and unexpected on the street.

For now Conor is keeping both outside and inside (his terms) work going. In 2009 he joined a bunch of street artists (including Lucy McLauchlan, Vhils and Sam3) for the FAME show, an indoor/outdoor event organised by *Studio Chrome* magazine in Puglia, Southern Italy. Conor painted two sides of a tower for the event, introducing a 3-D element to the piece. The signature excellence was still very much in evidence.

LOGAN HICKS

Skilled stencil artist Logan Hicks is based in Brooklyn, New York. He started off as a screenprinter (at age 16) progressing to own his own business producing t-shirts commercially, then tried his hand at stencilling in 1999. This soon took over as his preferred medium as it matched the dirty and gritty nature of his subject, the city.

He says "I don't really consider myself a street artist, although it is likely that I will do work on the street again sometime." His stencil technique however, is second to none and, when seen in an urban environment (such as the 2008 Cans Festival, right), hugely exciting and inspiring to many other artists working in the street.

Hicks's work takes on familiar scenes from urban life – subway lines, buildings, crowded city streets – and gives them the attention and focus usually reserved for more traditionally beautiful landscapes. These works are graphic in nature, but have soft edges, and a gentle layering of monochrome colours. Hicks takes the architectural elements of the city and the people within it and, as the stencilling technique requires, breaks these down into shapes and outlines. Unlike simpler stencil techniques, Hicks does this in a way that allows the colours and layers to appear to seep into each other organically.

This subtlety is matched by the photorealistic detail of his pieces, and his use of perspective, where the lines of the city are used to draw the viewer into the image. Hicks talks about the city he paints as "alive; a breathing creature where the ebb and flow of people washing over its sidewalks act as cells circulating through its veins. Buildings block passageways, walls block views, doors hide openings. The outside world is effectively shut out while the city creates its own reality. Confined spaces on subways, honeycomb living structures; it is a labyrinth of working systems."

The varied textures of different cities is what inspires him, so being able to travel abroad for exhibitions as he has increased in popularity has been a huge bonus for Hicks, who says "travel is easily the single most important thing in my work."

His intricate, complex way of working, pushing the boundaries of stencilling, make Hicks popular with other street artists. Yet he shows little patience for those who ask for the secret of his technique, which he says is the result of practice, not a trick that can be learnt overnight "here is how I gained my knowledge – I worked. I worked every day, every week, every year. I tried different things until I found the one that worked. There is no shortcut in making good stencils."

He told *Behance Magazine* that his advice for other artists would be that "I succeeded because I became oblivious to the reasons why I shouldn't succeed. At the end of the day those that are meant to succeed will find a way to do so, regardless of what I (or anyone else) says, and regardless of the hurdles that they face."

RIGHT: This pair of stencil paintings were done opposite each other at London's first Cans Festival in 2008. The top one is called *The Nerve System*, below that is a self-portrait of Hicks on the NYC subway.

95

INSA

LEFT: This old underground car is all legs and heels at the Village Underground in East London (taken 2008). **BELOW:** A signature red heel wheatpasted to a Shoreditch, London door (taken 2005). **BELOW RIGHT:** A sticker of legs and heels affixed to the rear of this Farringdon, London street sign (taken 2005).

"Insa was a name I made for myself about 15 years ago to write on walls" Insa told *Juxtapoz Magazine*, "these days my work revolves around sex, money, obsession, consumerism, materialistic objectification and shoes."

Providing a critique of sexualised, fetishised female forms may be one of Insa's artistic objectives, but he has shown himself to be a master of visual branding and, subsequently, a creator of

amazingly desirable consumer objects himself. He quickly established his signature logo – the classic fetish high heel – with stickers placed all over London's East End, and developed this as an endlessly repeatable pattern, at once brilliantly flexible and alluring, with more than an echo of Hans Belmer. His pictures of a spaghetti of legs, full of heels and sexual promise, were also wonderfully evocative bits of design, whether wrapped around the end of an underground train carriage, or high on a wall.

The success of the design made it instantly fashionable and Insa's *Air Force Fetish One* sneakers were a sellout. Having used the fetish heel as an icon it was only a matter of time before he produced his own line, in conjunction with shoe designer Ruth Shaw. But

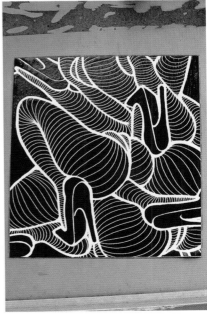

INSA

Insa has not stopped there. He has collaborated with some very big, very mainstream brands, lending them some of his fetish cool, Jaguar and VW Golf amongst them. There have been some more surprising collaborations, including creating a high-heeled room for the Ice Hotel in Sweden, and some more logical ones such as his work for Chicago rubber fashion label, House of Bias.

None of this has spoilt Insa's work though; if anything it has energized him. In 2009 he was still happily painting walls in Shoreditch, East London, going back to reclaim spaces where his previous work had been buffed.

The output is prolific, including jewellery and gallery pieces, featuring girls with their buttocks or breasts covered in thick electric pink and green paint. In the process he has managed a crossover into the hot rod and pinstriping scenes, and has created a calendar with the Fuel Girls. Street and commercialism in a unique union.

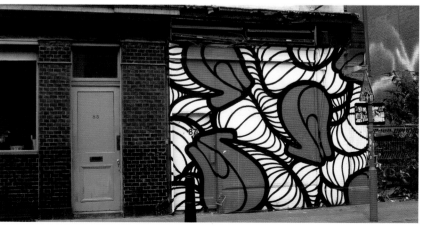

ABOVE: A wall painting tucked in behind a massage parlour in London's Old Street (2008). **LEFT:** Insa's signature heels cover this boarded up house near Bethnal Green Road, London (2009).

INVADER

Trying to spot an Invader, a square of mosaic tiles which bear the image of the artist's now ubiquitous character, is an addictive practice. Walk around any of the cities listed on Invader's website, and look out for tiled representations of the Invader symbol high up on walls or hidden low down on the corners of buildings and you will be surprised by the frequency with which the designs appear. For Invader, the art project he calls "a reality game" is also an addictive enterprise, which he has pursued since 1998. The aim? To invade urban spaces

with his visual signature, inspired by the Space Invaders arcade game, released in 1978. Invader's website lists a scoring system based on the amount of invaders that have been put up in each city. The list covers major street art locations like Tokyo (75 Invaders), London (101 Invaders) and L.A. (134 Invaders) to more off-track cities such as Istanbul in Turkey (20 Invaders), Dhaka in Bangladesh (7 Invaders) and Ljubljana in Slovenia (20 Invaders and "one hidden bonus.") The most impressive invasion, which is described

INVADER

as "in progress," is in the artist's home town Paris, with 704 Invaders stuck up around the city.

Invader says he has been working on the project for over ten years. He creates the unique mosaics (usually ahead of time), decides the locations he is going to hit and then attaches the pieces using cement. He says "it takes at least two weeks to invade a city. I don't just put up a couple of Invaders in the centre then go home. I set out to cover the entire city." The Invaders are sometimes positioned to appear to interact with the locations in which they are placed, so their eyes will peer around a corner, or they will be cheekily hidden just beneath a CCTV camera. Invader uses tiles because of the pixelated effect they create. For his recent work he is using Rubik's Cubes (to create both on-street and gallery pieces), which have a similar effect, arranging these to create pictures and sculptures.

On his motivation for producing art for the streets, Invader says "the act in itself is political" but "otherwise, it's more

BELOW LEFT: A large 30 point Invader (LDN_075) from London's 4th wave in 2006 watching over the Dragon Bar in Shoreditch, London. This unique piece was demolished along with the building in early May 2008 (taken 2007). **BELOW:** A 10 point Invader (LDN_018) near Abbey Road is from London's 1st wave in 1999. When taken in 2001, this was the location of the Saatchi Gallery. **RIGHT (clockwise from top left):** This Invader

(LDN_009: 20 pts) from London's 1st wave in 1999 has survived the test of time and has become a part of Covent Garden's landscape (taken 2005). // LDN_078 is on the same wall in Shoreditch, London where Bansky stencilled his *Snorting Copper* and is from London's 5th wave in 2006 (taken 2007). The damage seen in this image was later repaired during the 7th wave in 2007. // A colourful 20 point Invader (LA_054)

from LA's 2nd wave in 2002 on Melrose Ave (taken 2003). // A unique 20 point Invader (LDN_082) from London's 6th wave in 2006 in an alleyway near the Globe Theatre (taken 2007). // LDN_032 in Soho (20 pts) is from London's 1st wave in 1999, but continues to invade London after nearly ten years (taken 2008). // An old Invader from NYC's 1st wave in 2000 on Greene St in lower Manhattan was captured in 2001.

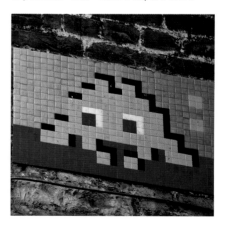

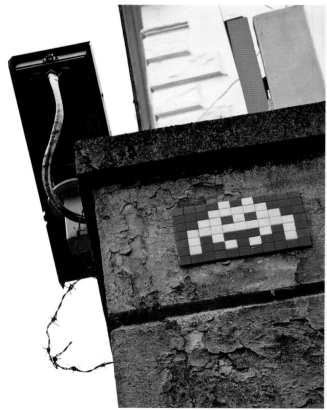

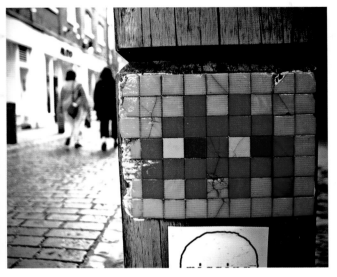
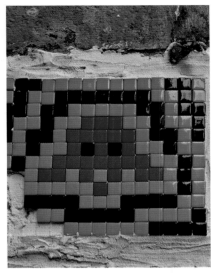

INVADER

an experiment...Obviously there's the gaming aspect too...the sole objective [is] getting a maximum score...each Space Invader is worth between 10 and 50 points depending on its size, composition and where it is. So each invaded city has a score that's added to previous scores."

He believes it's good for people to have something fresh to look at, such as the Invader in London who turns the table on advertisers, pointing a CCTV camera at a billboard. "If there was not artists like me to make things in the street there would only be advertising everywhere. Advertising is just kind of Big Brother... not to make people happy or to show nice pictures. Its just to make you spend your money and to make you buy... That's why I think I'm not a vandal, what I'm doing is good for the population."

LEFT (clockwise from top): A 30 point Invader (LDN_055) in Soho, from London's 2nd wave in 2003. // A unique 30 point Invader (LDN_086) from London's 6th wave in 2007 is next to the Old Street bridge in Shoreditch, London. This is the same bridge that was home to Banksy's happy riot police five years earlier (taken 2007). // A large and unique 50 point Invader (LDN_101) from London's 8th wave in 2007 is visible from Shoreditch High Street (taken 2007).

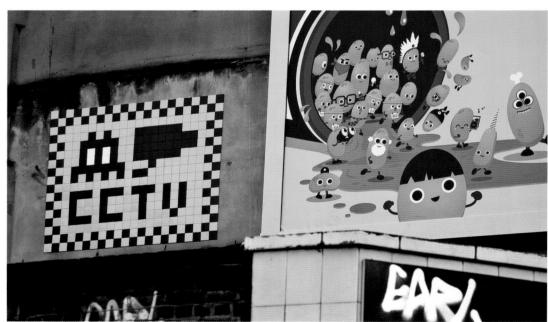

JEF AEROSOL

BELOW: A contribution to the 2008 Cans Festival in London.
BELOW RIGHT: Playing a flute on Great Eastern Street in Shoreditch, London (taken 2007).

Jef Aerosol started painting on the streets in 1982, and is part of the first generation of French street artists. His contemporaries include Blek le Rat, Speedy Graphito, Miss Tic and Jérôme Mesnager. Since the early 80s he has been producing stencil works, either painting directly onto walls or onto paper which he then pastes up. Born in 1957, Jef Aerosol lives and works in

Lille. He has travelled to numerous cities to work including London, Zurich, Paris, Chicago and in 2009, China, where he produced work at *Art Beijing* and on the Great Wall itself.

His focus is on people, usually portrayed at life size. Sometimes these are anonymous figures such as his famous *Sitting Kid* stencil, a seated boy with his arms gripping his knees, and his head bowed. He also paints celebrities, or more accurately, cultural (or counter-cultural) icons – including Nick Drake, Woody Allen, Bob Dylan, Mick Jagger, Joe Strummer, Ian Curtis, Syd Barrett and Sid Vicious.

Jef is also a musician, who has played and recorded with several bands – including Open Road and Distant Shores – and the influence music has had on his art is obvious. As well as affecting his

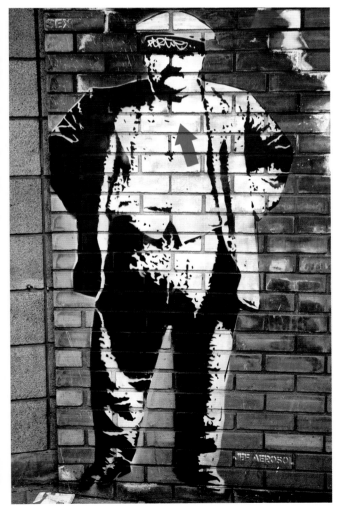

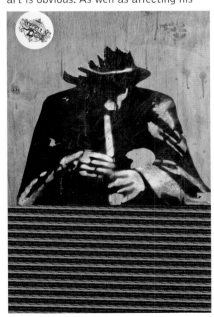

JEF AEROSOL

choice of subject, Jef even credits music with inspiring his style of street art "what made me want to use stencils was The Clash. I had been a fan of the band since they started and had noticed their stencilled shirts and leather jackets... I loved that! I think this was the real starting point, way back in the late 1970s..."

At this time Jef was creating posters and album covers in Nantes, then moved to Tours, and wanted to find a way of making himself known to the music scene there. He decided to make a stencil from one of the photo booth self-portraits he had been working on

and went out and sprayed it around Tours one night "I added 'Aerosol' to my first name Jef and that was it. Within a week or so, lots of people knew me or wondered who that Jef Aerosol was... Pretty soon, I found myself painting on stage with bands, showing my work in bars and music venues, in festivals and street happenings."

Jef names Andy Warhol and Ernest Pignon-Ernest (who created life-size silk screen portraits) as influences from the art world, and was "lucky to meet [Ernest] and be in a show with him, I felt proud and honoured to share the bill with Ernest."

BELOW: The crouching boy sits among pigeons near a huge Broken Crow stencil, at the Cans Festival in 2008. **RIGHT:** A paste-up of Nick Drake on a wall near Hoxton Square, London (taken 2007).

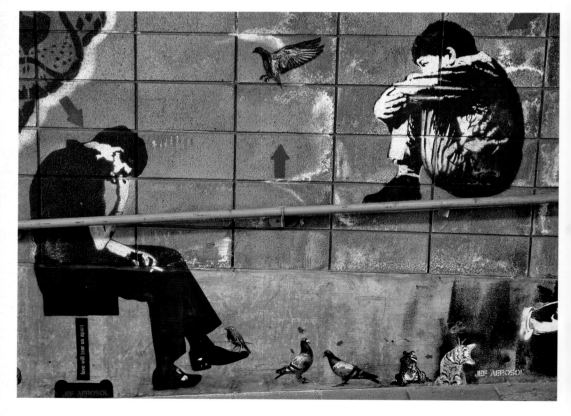

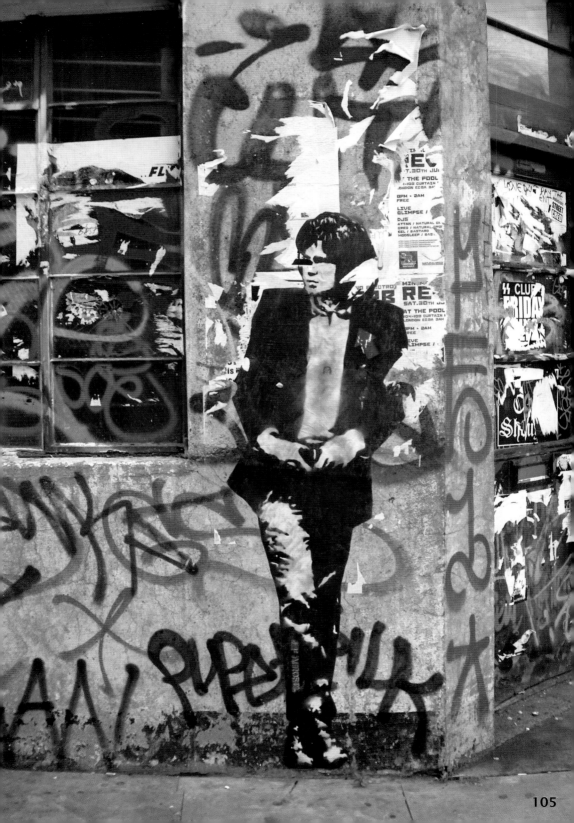

MARK JENKINS

LEFT: Mark Jenkins' body bags dumped on Tottenham Court Road, London in 2008. **BELOW:** A doctored sign in Malmö, Sweden, seen in 2008.

Recognised as the first celebrity 3-D street artist, Mark Jenkins recreates sculptures of his own form from clear packing tape, which he positions in various unlikely urban settings, sometimes clad in his old clothes, sometimes uncovered. Born in Fairfax, Virginia, and graduating from Virginia Tech with a degree in geology, Jenkins initially settled in Rio de Janeiro, and taught English. A fan of Bellmer, Goldsworthy and Munoz, in 2003, on a whim he began his tape experiments, eventually taping his whole apartment, and then himself.

The first perfect reproduction of his own form, thrown in a dumpster in Rio, attracted attention, and the out-of-body experience he felt when the dumpster destroyed his 'body', convinced Jenkins he was onto something. He subsequently produced giant sperm, pushing them out into the ocean and seeing the reaction of bathers as the tide brought them back onto the beach.

Back in Washington in 2004 he began a series of unauthorised installations of tape men on the sidewalks (he refers to them as 'embeds'), in the form of beggars or men waving at passing traffic. His work in what he calls "the cemetery" (Washington) seeks to resolve the sterility of the nation's capital, to shift viewers' perceptions into recognizing some of the weirdness that lies around them. He treats the city like a puzzle with myriad opportunities to provoke thought: "my mind's like a Rubik's cube" he says.

From casting men he started producing all sorts of forms, from a series of clear tape babies, to prostitute pandas, to floating water spiders, to clear dogs fighting over discarded bags of rubbish. His work contains heavy doses of satire, such as the parking meters outside the Department of Energy that he turned into lollipops. The interaction between his figures and the viewers are part of the work: Jenkins videos the reactions. Occasionally the installation is animated by its setting, as in the horses mounted on lampposts at Thomas Circle, a busy traffic roundabout in D.C.; the horses, facing the opposite way to the flow of traffic, created the illusion of galloping movement.

He now travels the world: Tokyo, Barcelona, Norway and Sweden. In Malmö in 2009, one of his 'embeds' showed a graffiti artist, lying dead on the pavement in front of a work in progress, with a knife in his back, his brush sketching an erratic line as he fell: another brilliant piece of provocation.

JR

JR is a 25-year-old Parisian photographer and street artist who works on a huge scale, pasting black and white prints of his photos on urban buildings. People are his subject, and they take on gigantic proportions in his works. JR used to graffiti in Paris in his teens, and began taking photographs after finding a camera on the Paris Métro when he was 17. His background meant that he found it logical to put his first photos in the street.

In an interview with *The Times* JR talked about the experience of working with people in slums and shanty towns, as he did for the projects he has recently installed in Kibera in Kenya, and the Morro da Providência favela in Rio, Brazil. He covered the exterior walls of selected shacks in the favela in pasted-up photographs he had taken of local residents as part of his *Women* project, with faces (and close-ups of eyes) enlarged to the height of a house. The effect is a tapestry of faces interrupting the brick walls of the buildings which cover the hillside in a jumbled fashion, a vivid imagining of how the people inside could be staring out at you. "When I explained to them in the favela that my work sells for a lot of money, nobody tried to kidnap me. Nobody begged from me. When I told them I don't pay my models for posing for me, they were okay. I explained to them, 'If I pay you, we lose the whole soul of the project.' People who want their stories to be heard will do it without getting paid."

JR puts money back into the places he visits to photograph, and has opened a cultural centre in Rio which will allow people from the favela to visit and create artwork. This is important to JR as he says that when he returned to Morro da Providência a month after the project, many of the kids who had helped him with the works were dealing drugs again, yet he maintains that "what I do does not change the world...it can only make a difference to how a few people look at the world."

In Kibera, JR covered the roofs of houses in portraits (again with a focus on eyes and mouths) and also pasted a set of eyes onto each carriage of a train that goes past the settlement, and installed three carriage-width pictures of noses and mouths on the hillside below its tracks. This had the comedic effect of a changing set of faces, with the portraits taking on different expressions as the train passed and the eyes on each carriage aligned with the rest of each face. JR used waterproof materials for the images he placed on the rooftops, as he realised that in places such as Kenya people often don't understand the motivation for producing art for art's sake "food is their first need. They don't do art just for the love of art. It has to make sense. By making their roofs rainproof, what we did made sense. They loved it."

For his *Face 2 Face* project in the Middle East (in collaboration with Marco) in 2006-07, JR took "portraits of Palestinians and Israelis doing the same job" and posted them next to each other, "face to face, in huge formats, in unavoidable places, on the Israeli and

RIGHT: JR's massive wheatpaste on Tate Modern's façade as part of its 2008 *Street Art* exhibition. This piece welcomed all visitors approaching the museum via the Millennium Bridge. Viewing it from across the Thames gave the impression of the figure holding a weapon rather than a camcorder.

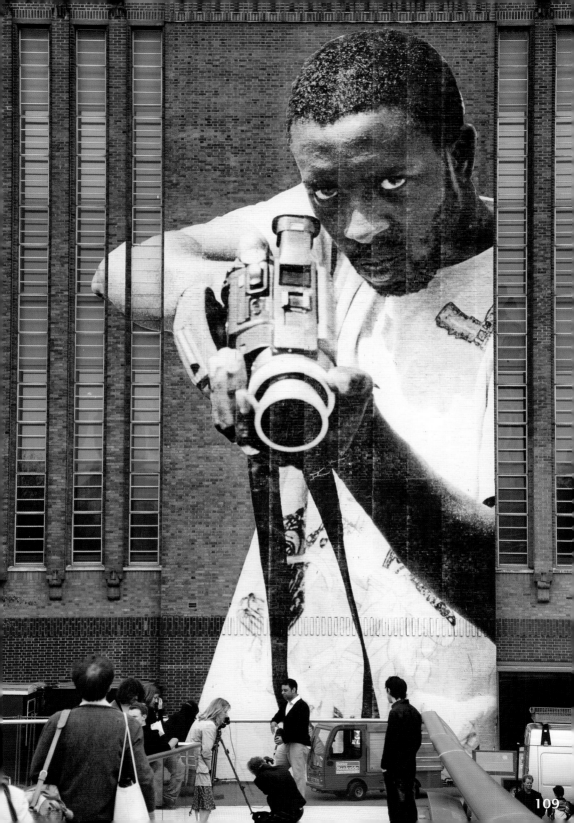

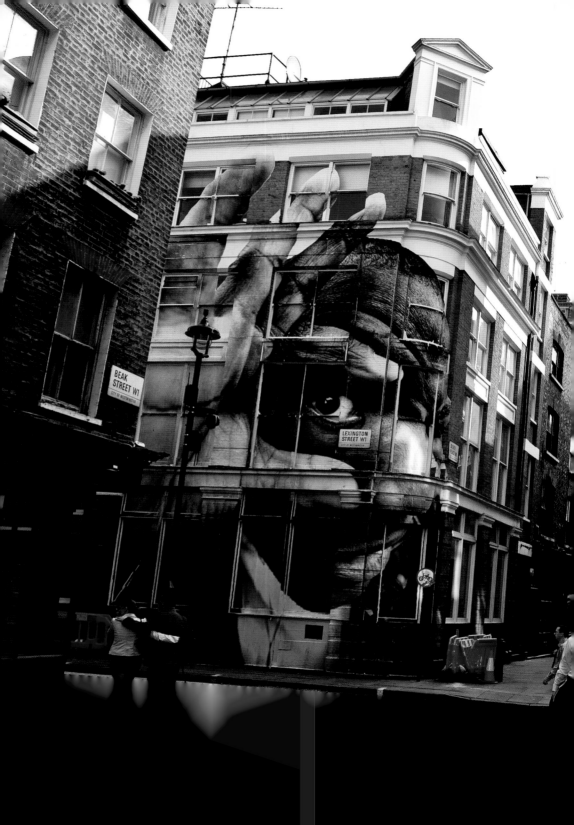

JR

LEFT: A huge JR piece in Soho, London. This piece went up simultaneously with a few other massive pieces throughout London coinciding with his participation in Tate Modern's 2008 *Street Art* exhibition.
BELOW RIGHT: Another JR piece put up to coincide with Tate Modern's 2008 *Street Art* exhibition, this time in London's Old Street.

the Palestinian sides." This included photographs of a Rabbi and an Imam, pasted in locations including the West Bank. The project sparked controversy and JR was arrested for trouble making by the Israeli army. He says that the "41 heroes" who agreed to be photographed are neighbours, but usually only see each other through the media. The aim was simple: to increase understanding between Israelis and Palestinians. He hoped at least that everyone involved

in the project would "laugh and think" when they saw the portrait of their neighbour next to their own.

JR works in black and white because it is cheap and not typical of the advertisements his work competes for space and attention with. "Normally," says JR, "you have to be very famous to have your picture blown up so big. But these are just ordinary people, with everyday stories."

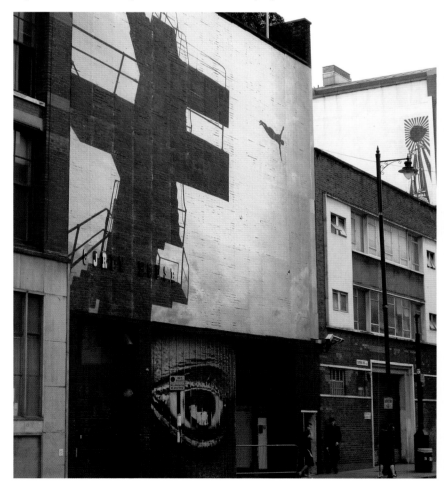

KAMI

LEFT: Seen under the rail tracks in Nakameguro, Tokyo (taken 2004). **BELOW:** Kami's iconic logo placed on top of this fence in Nakameguro, Tokyo (taken 2008). **BELOW RIGHT:** Kami's logo seen on Tokyo's Aoyama-Dori in 2004.

Kami is originally from Kyoto but has lived in Tokyo for over a decade. His work is influenced by Japanese calligraphy and skateboarding, which can be seen in the elegant graphic style and clean lines of his pieces. "I try mixing Japanese culture and I used to be skateboarder long time, so I try mixing skateboarding and street culture with Japanese culture in my painting."

"Japanese grow up real different in the streets. I'm from Kyoto, it's a small town, but really old. They have many temples, shrines, long history, and really Japanese. I can't see graffiti before, like 15 years ago. Now I can see some, it's like American culture." As well as embodying the flow of skateboarding (and skateboard graphics) and calligraphy, the lines in Kami's work take inspiration from "nature, like Kyoto, like a beautiful river."

He sees his street work as painting outside, rather than graffiti, and has produced collaborative works with his wife, Sasu, under the name Hitozuki. These have appeared in galleries and on the street. In addition to his painted work, Kami's dummy tag can be seen around Tokyo. He participated in the exhibition *Insiders, Outsiders, & the Middle* along with street artist Invader in L.A. in August 2008, showing new works on canvas, and is part of the Barnstormers collective.

MBW

"I don't know if I am an artist, but one day I decided no longer to sit in the back, now I will take control of the car", said Mr. Brainwash (a.k.a. MBW) recently, in his inimicable French accent.

For nine years this French film maker toured the world to make the most iconic documentary about street art. Inevitably, perhaps, he decided not just to film 'em, but to join in. In a short window he went from designing a few hand-drawn stickers to making hundreds of giant paste-ups that he plasters on the walls of his adopted home town, Los Angeles.

Dubbed "Warholian" by the New York press, MBW essentially mashes icons of US pop and political culture, from Warhol's own Campbell's soup cans reinvented as spray cans of tomato soup,

to the kissing moment on MTV between Madonna and Britney, recreated as a barcoded image.

In 2008 MBW mounted his very first exhibition *Life Is Beautiful* at the old CBS studios on Sunset and Gower in L.A.. For several weeks he worked nearly 24 hours a day to get rid of all the partitions, desks and detritus to recreate the mood and feel of a 1930s studio.

He filled his re-born space with his signature images: six foot-tall barcoded Mona Lisa paintings, huge stencilled art pieces of Miles Davis, Veronica Lake, Alfred Hitchcock, 8-foot tall spray cans, a life-size recreation of Edward Hopper's *Nighthawks* and an installation made from 25,000 books.

BELOW: A paste-up of Madonna and Britney Spears' famous kiss seen in central L.A. in 2008. **RIGHT:** The artist's self-portrait is found in many cities around the world. This paste-up was seen in L.A.'s Artist District in 2008. **BELOW RIGHT:** A stencilled 'evolved' take on Madonna and Britney's kiss at the Cans Festival, London 2008.

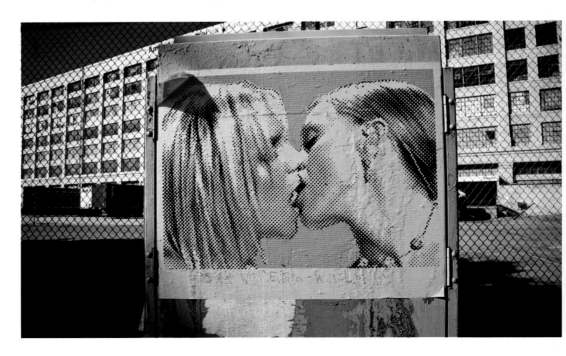

MBW

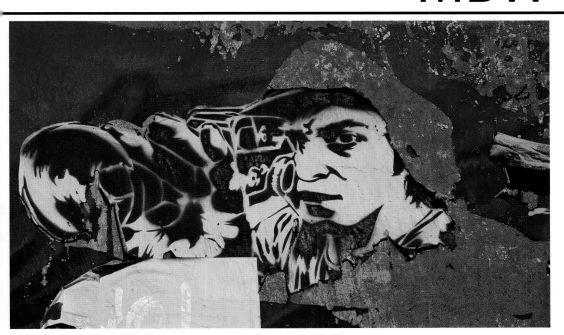

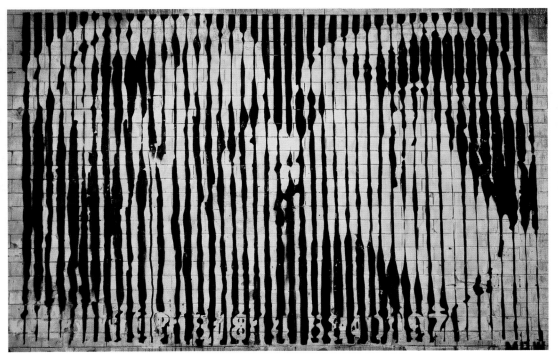

MBW

MBW is admired by his peers. Banksy invited him to take part in the Cans Festival in London; he described a gift from MBW – a 7ft x 3ft hand-sprayed piece – as "fucking incredible". It is his huge energy and sense of scale that engages: MBW turned a wall on La Brea and San Vicente into a personal canvas, creating in turns a Jackson Pollock drip painting, the Mona Lisa mooning, Marion Cotillard from the movie *Piaf* (remember he is French), Madonna/Britney and scenes from *Star Trek*.

For Obama's inauguration he repainted the wall, with a legend on the side stating 'Rosa Parks sat, so Martin Luther King Jr. could walk, Martin Luther King walked so that Barack Obama could run, Barack Obama ran, so we could fly.'

In other work MBW has stuck a Marilyn wig on portraits of stars and politicians: Jack Nicholson, Larry King, Obama and Warhol amongst them. With true Gallic originality he has also done portraits of stars in shades: Marilyn, Ray Charles, George Lucas, Steven Spielberg, Woody Allen, Bob Marley, W.C. Fields and Hitchcock. The selection is puzzling; in an underpass at Argyle and Franklin we find Louise Brooks and Yakov Smirnov: remember Smirnov? Neither do we.

BELOW (clockwise from below left): Elvis plays a Fisher-Price machine gun at the London Cans Fest (2008). //George Lucas and Steven Spielberg in shades in L.A.'s Artist District. // Warhol-esque spray cans at the Cans Fest, London (2008). **RIGHT:** A sunglasses-wearing skeleton in L.A.'s Artist District.

BARRY McGEE

LEFT: A classic Barry McGee face found on a Shoreditch, London doorway that was once home to the Modern Art Inc gallery where he participated in multiple exhibitions (taken 2007). **RIGHT** An example of his iconic screw tag near the train depot in downtown San Francisco (taken 2002). **BELOW:** A McGee face in San Francisco (taken 2003).

Also known by other monikers, including Ray Fong, Twist and Twister, Barry McGee was born in San Francisco in 1966. Introduced by a friend to graffiti, he became one of the major taggers in the Bay Area in the 1980s. Deciding he needed to get to know art techniques, he signed up to the SF Art institute, and graduated in Fine Art and Printmaking in 1991.

Universally recognised as an exceptional talent, his influence has also encompassed skaters and surfers.

He developed several now common techniques, including the use of paint drips and the 'gallery' technique of clustering paintings. The latter, inspired by South American Catholic churches, emerged after his trip to São Paulo in 1993, where he also heavily influenced Os Gêmeos.

His work is in large part a reaction to the oppressive colonisation of the urban streetscape by commerce and corporations; he has described the urban experience as "urban ills, overstimulations, frustrations, addictions and trying to maintain a level head under the constant bombardment of advertising."

Typical McGee work involves huge, wistful, transient street figures, often with empty bottles of liquor. There is genuine, yet challenging empathy in the

BARRY McGEE

work. He continues to view graffiti as a vital method of communication and has turned down representation offers from many galleries. As a sign of his importance, significant dealers are still happy to show his work on an *ad hoc* basis.

McGee has also had hugely successful museum shows, exhibiting solo at Yerba Buena Center for the Arts in San Francisco (1994), the UCLA Hammer Museum in L.A. (1999), the Prada Foundation in Milan (2002), the Meat Market Gallery in Melbourne (2004), The Rose Art Museum in Boston (2004), The Watari Museum, Tokyo (2007) and at Baltic, Gateshead, UK (2008) – to name only a selection.

Curators know they are dealing with

someone with a bit of an outlaw sensibility, but they equally respect the fact that his work remains unpredictable and edgy, unsoftened by the gallery environment.

McGee's installations are iconic – as in the Ford Econoline truck upside-down in a dumpster outside the entrance to the Rose Museum show, or the graffiti-covered truck 'crashed' at the entrance of the Yerba Buena Museum for their 10th anniversary show (the police demanded its removal so tired did they get of 911 calls reporting the 'accident').

He still stays in the game, recognised by a new generation of street artists as 'The Godfather', although the graffiti he now paints on the street he does entirely anonymously.

BELOW LEFT: McGee in the car lot of the Los Angeles County Museum of Art (LACMA) in L.A. (taken 2005). **RIGHT:** A McGee piece in San Francisco (taken 2007). **BELOW RIGHT:** A Barry McGee piece among barrels in San Francisco (taken 2005).

LUCY McLAUCHLAN

LEFT: An improvised piece painted on a wrecked car as part of the London Cans Festival 2 (which took place in the same location under Waterloo after the first Cans Festival in 2008).

Originally from Birmingham, Lucy McLauchlan now lives and works in London. Her detailed work has a psychedelic feel but is always depicted in monochrome tones, primarily black and white.

McLauchlan started out doing illustration and then moved on to larger scale pieces, describing her way of working as 'improvised' as she does not plan it before starting. She started out using permanent marker pens and Indian inks, but moved onto paint for her large scale works.

McLauchlan says that "using permanent materials presents a challenge, the mistakes often turn into my favourite details within a piece." The video of McLauchlan painting the installation piece *Tacit,* created at the New Art Gallery Walsall in Dec 2008 as part of the *Outsiders* show (featuring work from artists represented by Lazarides) shows the fluid, bold way in which she paints. *Tacit* (the word is defined as something that is implied, or understood without being openly expressed) was painted directly onto the gallery's white walls, incorporating found objects and urban detritus such as video cassettes, lampshades and mannequin arms, which were painted then added to the wall piece. McLauchlan paints in confident, smooth lines, apparently creating the work from nothing, with no pencil outlines or planning visible.

The *Tacit* video was filmed by Matt Watkins and features a soundtrack created by Watkins and McLauchlan based on the music of John Cage and

inspired by Lucy's work. Watkins and McLauchlan founded 'Beat 13', an art and music collective and a website to show and organise their work, in 1999. It then became a gallery, including work by other artists. They say that "it all started with drawing, music instruments came next, and then came the computers." They explain that "we created various projects, exhibitions, comics, screenprints ... all involving friends and acquaintances."

McLauchlan says that she avoids colour because she enjoys "concentrating on the line work, sometimes colour is distracting — I use it occasionally but find the tones already existing on the surfaces of the found objects I use more interesting."

The works McLauchlan creates on discarded objects and walls have a quality of repetition and flow that seems like doodling — on a vast scale — in a way they appear to have been produced for the joy of mark-making.

Some of her recent work also has a political angle, in the materials she has chosen — her work for the opening of the new Lazarides Gallery in London in May 2009 saw her use police riot shields as canvases. The abstract lines and circles McLauchlan painted on to the transparent shields in white and grey gave them a delicate quality. She says she was "inspired by recent protests where peace doesn't seem to be on the Police's agenda ... what a surprise. Don't let our most powerful voice be under threat."

MICROBO

Microbo, based in Milan, Italy, creates biologically-inspired micro organism characters, which appear to float across urban surfaces. These creatures are produced using a variety of methods – hand drawn, stuck up on stickers, wheatpasted (from hand drawn sketches scanned in to the computer and printed on a large scale) or painted.

A designer and illustrator, Microbo is married to fellow street artist Bo130. On the streets of Milan, London, Berlin, when a Microbo piece is found a Bo130 piece can usually be seen nearby. The two collaborate on murals and also work alongside each other in gallery shows, with the two artists' distinct styles overlapping.

Microbo's work is delicate and detailed, and recent paintings on wood panels show the surreal beauty of the creatures and micro landscapes which obsess her. She remains most excited by working in the streets, however, finding that they "are human in the sense that they do not demand academic prejudice or prerequisite knowledge, but draw real emotional responses."

Microbo is also motivated by a desire to produce a visual alternative to commercial imagery. "I think it is important to have unsolicited aesthetics in an overwhelming image economy with an inherent sales agenda. Its interesting to paint on all different surfaces as well." She says she was drawn to work in an urban environment as it involved risking something. "I liked the idea of sharing my work with the public, and the vulnerability of this as I learned from each reaction."

BELOW: "Hello my name is..." sticker found adjacent to a Bo130 "Hello..." sticker in East London, 2003. **RIGHT (clockwise from top left):** A painted Microbo in Barcelona's Raval district (taken 2005). // A Microbo scrawling on a Barcelona wall shows a slight evolution of the basic character (taken 2005). // Three out of a swarm of Microbo stickers found on this Shoreditch, London lamppost. As is typical of Microbo's Work, a Bo130 sticker can be seen here sharing the location (taken 2003). // Another evolved microbe scrawled on a wall in Barcelona's Raval (taken 2005).

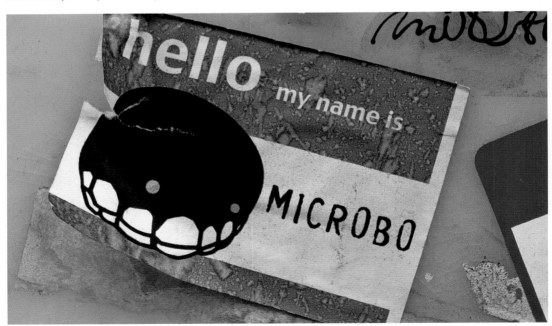

125

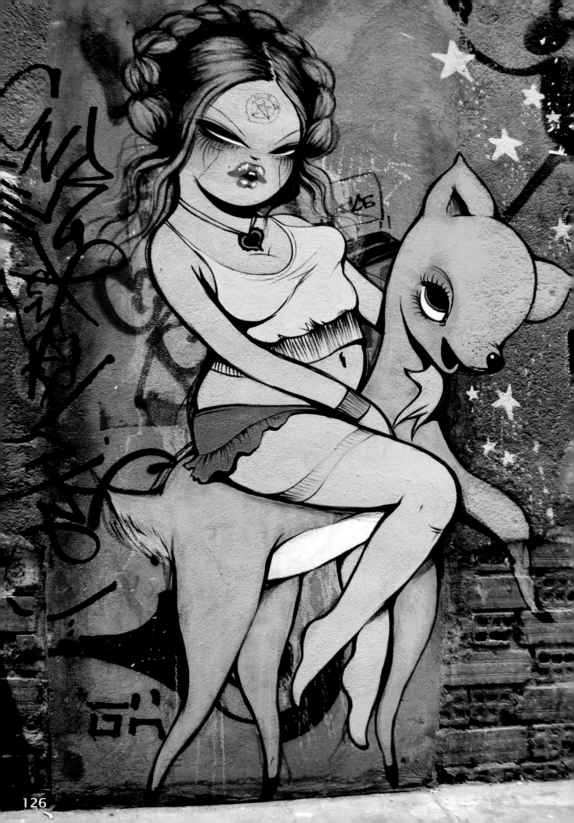

MISS VAN

LEFT and BELOW:
Two views of this piece in Barcelona's Ciutat Vella, with the other artist's piece wanting to get cosy with the girl on her deer (taken 2005). **BELOW RIGHT:**
Close-up of a *poupée* by Miss Van behind Barcelona's Mercat de La Boqueria in 2005.

Miss Van (real name Vanessa) was born in Toulouse in 1973, and now lives in Barcelona. She started painting female characters in 1993, using acrylic/latex paint, an unusual material for a graffiti artist. She likes the way the paint allows her to create pieces without making any noise (unlike spray paint) and which contrast sharply with the walls they are painted on, making her figures jump out from the buildings in bright, opaque colours, as if they are large-scale stickers.

Miss Van began painting with Mademoiselle Kat, who she met when studying art at university. She told *Swindle* magazine: "I guess we created something like a feminine movement in Toulouse, supported by the guys, and then the graffiti scene became more and more important in Toulouse. Also, Toulouse was a more tolerant city, and police got confused by seeing girls paint."

Miss Van's images of women were painted alongside other graffiti art in the city, but from early on the characters she created had a different energy and motivation to the wildstyle lettering the guys were putting up.

The women she paints, which she calls "Les poupées de Miss Van" (Miss Van's dolls) are sexy, feline creatures, intended to "disturb or seduce people on the street." Some have found the images offensive, and paintings in Toulouse were even attacked in protest, Miss Van believing that feminists were responsible for blacking out the *poupée's* faces.

"I've met some guys that have had fantasies with my dolls and want to meet me, thinking I was like my drawings. I'm a little bit uncomfortable sometimes, but proud at the same time, provoking any strong feelings just using my imagination."

Miss Van says she paints women because she knows more about them than she does about men: "they could be sad, melancholy, arrogant, or expressing any sort of feeling, just like us. It's never been my purpose to only paint in a sexy

MISS VAN

sort of way. I just enjoy painting my fantasies without censoring myself." The *poupées* have an erotic, fantasy element to them, increased because they are often depicted making eye contact with the viewer. Meeting their gaze on the street is memorable; the figures seem to demand attention.

Miss Van now paints largely on canvas or wood panels, and says this has allowed her to concentrate more on technique, as she can work more slowly than she can on the street. She has had solo shows in New York, Paris and Barcelona. Despite a two-year collaboration with clothing label Fornarina to design limited-edition clothing, Miss Van says "I don't want to make so many products. I don't want to become a brand. I am just an artist."

BELOW LEFT and BELOW: These two girls were found behind Barcelona's Mercat de La Boqueria in 2005. **RIGHT:** A Miss Van *poupée* with bunny ears as seen in Berlin in 2007.

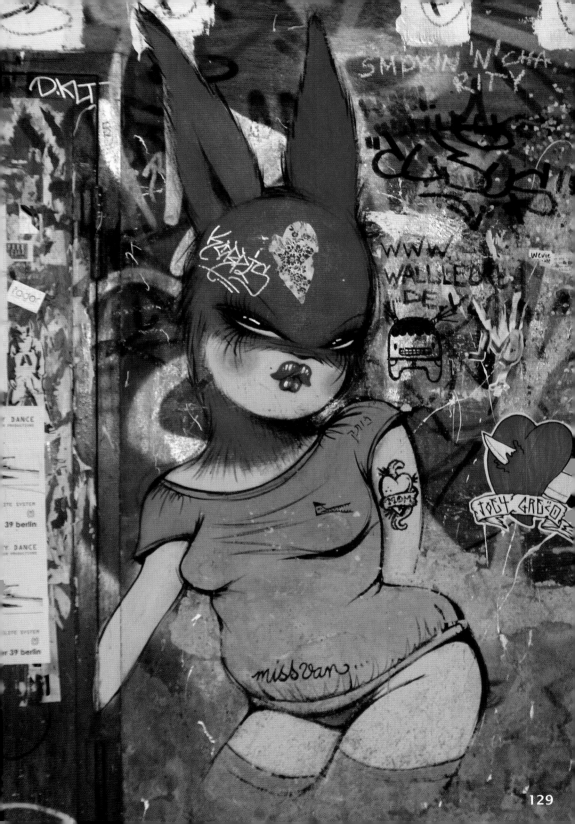

OS GÊMEOS

The year is way back in 1987, the place Cambuci, São Paulo, Brazil and Os Gêmeos (literally The Twins) were just starting to get into street art, whilst hanging out and break dancing with the hip hop crowd and with the practitioners of Pixação, the unique form of graffiti art that grew out of the São Paulo favelas (shanty towns) and took over the city.

With their hip hop influences Os Gêmeos (a.k.a. Otavio and Gustavo Pandolfo, born in 1974), were keen to emulate New York-style graffiti when they started. This was in the days before the

BELOW LEFT: A piece painted on a boarded-up storefront on L.A.'s Melrose Ave in 2003. Os Gêmeos' first solo Exhibition was in 2003 in San Francisco... might they have swung by L.A. on their way there? **RIGHT:** A huge piece on the exterior of Tate Modern in London, commissioned for the gallery's *Street Art* exhibition in 2008.

OS GÊMEOS

internet, when it was hard to get hold of source material, and very expensive to buy spray cans, so the two began painting in latex paints, which they transferred into stolen perfume-spray bottles. They would bomb the streets in daytime or on Sundays – "the national day of graffiti in Brazil, because it was more relaxing and the police are watching football on TV".

In retrospect, the fact that they had no information about other graffiti scenes helped. In trying to discover how things were done by trial and error, they discovered other avenues and techniques.

A chance encounter with Barry McGee (a.k.a. Twist) in 1993 proved a major catalyst for their work. McGee was on a study programme from the San Francisco Art Institute, and shared a lot of techniques, from throw-ups to tags. McGee also inculcated the notion of 'living through art', taking Os Gêmeos onto a different plane.

"At first we were the same as the others, painting B-boys and staying close to the themes of hip-hop...then we decided to go our own way". They found a voice, sometimes from São Paulo life, sometimes from an imaginary universe they call 'Tritez', and, having absorbed some outside influences, found the confidence to dig deep into Brazilian sensibility and folklore traditions.

An amazing universe of characters and colour was the result: "we report a vision of day-to-day life: simple scenes, sensually rich...illustrations influenced by our country, our roots, our folklore and our people." And yet the style is instantly recognisable. One signature is the heavy use of yellow with dark red: you can spot an Os Gêmeos work from afar. (There is an unwritten rule in São Paulo that street artists respect each others' signature use of colour).

Sometimes the pieces are there to provoke, to highlight social injustice or scandals. Sometimes they are just incidental portraits inspired by friends and family. But every character is a new creation: they never repeat.

Os Gêmeos did their first gallery show early – in 1997, in São Paulo, and their first international show in 1999 at Die Faerberei Galerie in Munich, Germany. This is when they began travelling, and, in addition to Europe and the USA, their work has now been seen in Cuba, China, Japan and Australia.

In 2002 they created *Chromopolis*, a large panel work for the 2004 Olympic Games in Athens.

In 2005, in recognition of their international influence they were invited to decorate two subway trains for the São Paulo CPTM network, a marked change from the time that all their work was buffed on mayoral orders. This was also the year they painted one of their favourite works – the 60-foot mural *Creative Time* on Stilwell Avenue, Coney Island, NYC. 2007 saw one of their stranger projects – the decoration of an entire facade of Kelburn Castle near Glasgow, Scotland.

A major exhibition in 2008 at Tate

OS GÊMEOS

BELOW RIGHT:
Sharing a wall with
Freaklub and Lolo
behind Barcelona's
Mercat de La Boqueria
in 2005.

Modern in London saw Os Gêmeos being
invited to paint one of their giant figures
onto the vast façade of the gallery. It had
been a 21-year journey from their first
paintings, but artistic accolades don't
get bigger than this. They remain true
to their roots, and have vowed to keep
their spray cans to hand, even when they
"grow old, fat and bald".

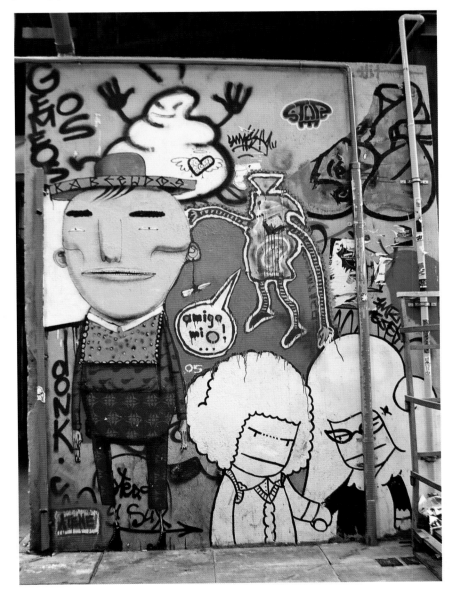

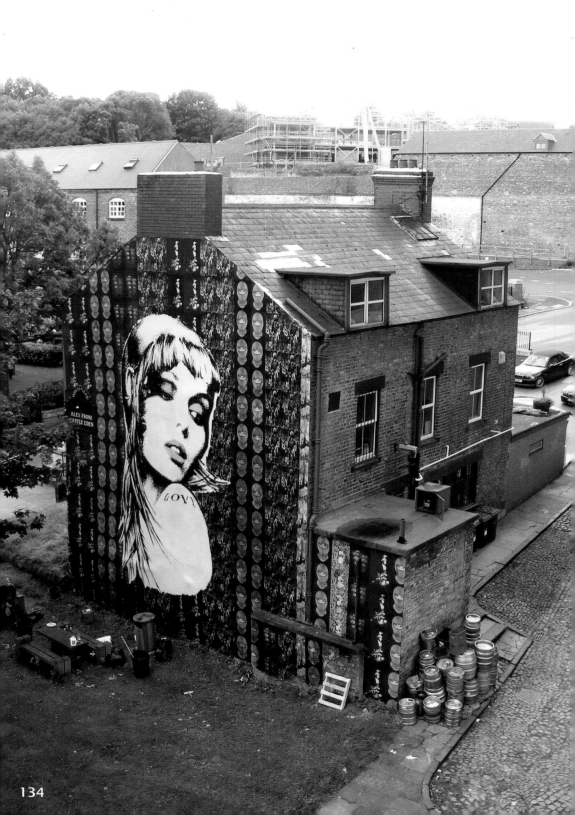

PREFAB 77

LEFT: A huge screenprinted paste-up on the side of The Ship Inn, Byker (Newcastle) in 2008. **BELOW (clockwise from left):** A Prefab *Heist* paste-up in Barcelona, Jan 2009. // A collection of *Heist* paste-ups are lit up by a traffic bollard in Newcastle, 2009. // A Prefab *Hyena* in Barcelona, Jan 2009.

Prefab 77 are a collective of three guys from Newcastle, in the North East of England. They produce their street work (usually in the form of monotone paste-ups, including large scale building-sized pieces) by first deciding the concept as a group, sketching, planning and then building the images up: "we shoot or find imagery, draw or paint layers, screenprint and hand-paint – whatever medium fits the piece." They find "we are very graphic in our approach rather than fine art, and this reflects our background." The meaning behind the work (titled with evocative phrases such as *Enemy of Promise* and *Youth in Disgrace*) is not explicit but the group sometimes use images of 'Britishness' to reference current issues, such as the financial crisis (the image of bowler-hatted bankers holding crowbars instead of canes titled *Thick as Thieves*) or more general social unrest and change (the exploding telephone box).

Asked to describe their work, Prefab put it like this: "dark, funny, beautiful, part fantasy, part social comment, fading institutions and emerging futures." Of their place in the greater street art

PREFAB 77

scene, they say: "The shame is when a 'movement' becomes a movement it's then that people start to think it's over. We think it's in healthy shape and the variety of artists, mediums and messages are great…they are our cities and we should all get out and decorate or preach or make each other laugh." As well as pasting up in their native Newcastle, Prefab have worked in London, Barcelona and Brighton and have plans for further travel in Europe and the US. Prefab are closely involved with the Newcastle shop Electrik Sheep,

a North Eastern outpost for street art fans. The shop has a gallery space which has hosted exhibitions by artists including Eelus and Pure Evil and sells prints by artists such as Above, Faile and Prefab themselves.

The sales pitch? "You can always warm yourself in front of one of our Prefab Originals. Most of our art is a mixture of acrylic, spray-paint, varnish and inks on wood or paper. Their flammability makes them a sound investment for the future as fuel prices continue to rise."

ABOVE: 30 ft *Enemy of Promise* paste-up in Brighton, April 2009. **TOP LEFT:** *Thick As Thieves* paste-up in Old Street, London (2008). **BOTTOM LEFT:** DM Boots in Byker, Newcastle (2008).

PURE EVIL

BELOW: Pure Evil *Pearly King* paste-ups opposite The Griffin pub on Leonard Street, where the Pure Evil Gallery is located (2008).

East London-based Pure Evil started experimenting with graffiti in California in the 90s. He began spraying his evil bunny symbol in London in about 2000 when he moved back to the city from San Francisco, where he had been a designer for clothing label Anarchic

Adjustment. Pure Evil was inspired by the work of Twist (Barry McGee) which he used to see on his way to work "when I saw his characters a light went on in my head and I thought 'I want to do that.' Obviously not as good as Twist though..." After deciding that "giving a gallery half my money was a stupid idea..." he opened the Pure Evil Gallery in London's Old Street. He showcases

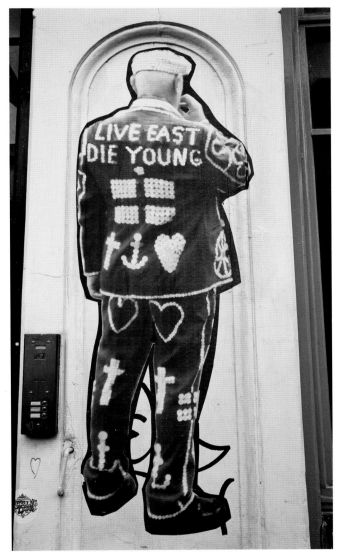

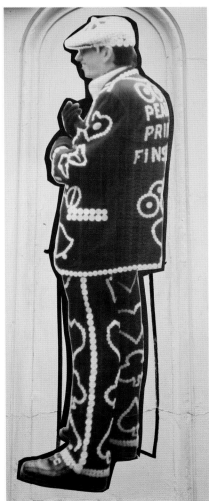

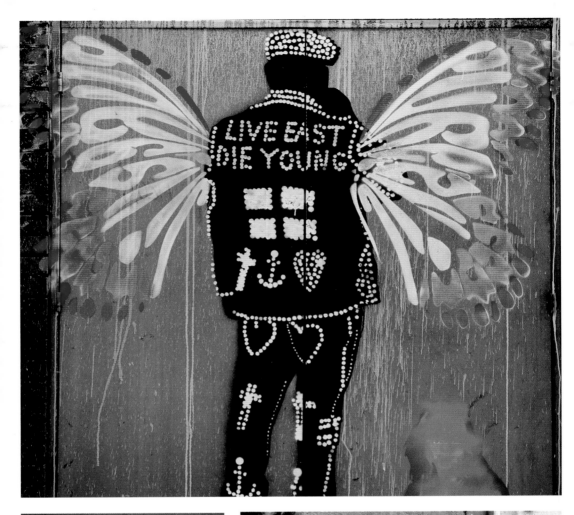

LIVE EAST
DIE YOUNG

I HAVE FOUGHT
FOR WAGE INCR-
EASES. I HAVE A
PLASMA T.V.,
A BIG FRIDGE &
A NEW CAR...
MY WHOLE LIF
IS BULLSHIT

PURE EVIL

LEFT (clockwise from top): *Pearly King with Butterfly Wings* stencil at the London's Cans Festival (2008). // A 'classic' vampire bunny painted onto a wall along East London's Kingsland Rd (taken 2005). // Stencilled piece at the Cans Fest (2008). **BELOW:** A Misfit bunny in Shoreditch, London as an homage to the band (taken 2005).

and sells his own work (screenprints and canvases based on his on-street stencils, paste-ups and images of the pure evil bunny) alongside that of artists such as The Krah, Eine, Doodles and C215.

The gallery is informal and Pure Evil says "artists from all over the world drop in and ask about good places in London to do work." He believes that as an artist he is more in touch with the real street art scene than traditional gallery owners and told *Time Out* "I can't imagine that an old-fart gallery owner will know the artists working at the moment."

"Street artists are more aware of the art marketplace now. But it's seeing what everyone else is doing that makes you want to step up your act. We're not doing it to be accepted by galleries but by our peers. Street art doesn't rely on reviews; there are no tastemakers."

Pure Evil says he is "inspired by death metal, rock zombies and home studio vampires everywhere" and describes his style as "pop gothic graffiti" and himself as follows: "he has no can control and he paints like a ten year old." As well as London, where his pieces can be seen all over Shoreditch and Hackney, he has worked in New York, Tokyo, Beijing, San Francisco, Barcelona and Hong Kong.

Pure Evil's father is a painter and undoubtedly an influence: "although I tried not to be an artist for a while, I have accepted my destiny as an artist." His work changes in style and medium regularly – creating the pure evil bunny in materials from spray paint to neon, stencils and paste-ups (like *Live East Die Young*), and paint – such as his *Heath Ledger* canvas, produced after the actor's death.

Pure Evil (who has also worked under the alias the So Fuzzy Crew) says his name comes from "a rabbit I shot when I was 10. I feel like the pure evil rabbit is probably the ghost of that one coming back to haunt me."

ROADSWORTH

Roadsworth is an underground celebrity in his hometown Montreal, where his funny, daring additions to street markings have transformed public space. Peter Gibson, the artist behind the 'Roadsworth' name, first started painting in the streets in 2001, largely stencilling pieces directly onto the road. Initially he sprayed cyclist symbols on roads as a way of protesting against the lack of cycling routes in the city, but then began to create images that interacted with the existing street markings. Gibson says that the pieces were "simple, open-ended, ambiguous," and "also somewhat integrated with the environment — the street, the road markings — giving them an almost subliminal quality."

"The humourlessness of the language of the road not to mention what I consider an absurd reverence for the road and 'car culture' in general made for an easy form of satire. In the spirit of Marcel Duchamp, all I had to do was paint a moustache on the Mona Lisa, so to speak."

In 2004 Roadsworth was arrested and charged with 53 counts of 'mischief' and it was speculated that he could receive fines of "$250,000, jail time and a criminal record." However a huge outpouring of public support for the artist (including 'Save Roadsworth' blog campaigns), and a debate that arose on the nature of public art and ownership of public spaces helped to protect him. Eventually the charges against him were dropped and he was given a minor fine and 40 hours of community work (creating artwork in Montreal). Roadsworth attributes the decision to

give him a more lenient sentence in part to "the public support...subsequent to my arrest."

Since then, he has taken on a number of commissions, including a piece for the 2007 Tour de France, featuring flying birds painted on the cyclists' route and participated in the London Cans Festival in 2008.

ABOVE and RIGHT:
Three classic Roadsworth pieces from Montreal in 2004, the year the artist was arrested for his street stencils.

SAM3

Born in Elche, Southern Spain, working internationally, and based in Madrid, Sam3 creates work that is instantly recognisable, but also constantly evolving and surprising. His characteristic signature pieces are the vast black silhouettes that he paints on billboards and on the sides of buildings, but his art also encompasses colour, some amazing animations and street sculpture from found objects.

In his street paintings, Sam3 always works with the context. In one of his earlier pieces from 2002 in Granada, he created a seemingly childish painting of a boat floating on squiggly waves, with the sun beaming down on the scene, inside a primitive frame. He painted the same scene in odd recesses left on the unfinished sides of buildings, on newly-buffed spaces on the streets of Granada, inside a TV set by the side of a shop

selling TVs, and, in a comment on street artists sometimes disrespecting the work of others, showing them painted on top of one another.

One of Sam3's concerns is the nature of the medium and a desire to comment on it. Inspired by Carlo Fontana's *Slash* paintings (the first artist to pierce the canvas in a comment on the restrictions of 2-D), Sam3 created a series of *Slash Billboards* in Murcia. A further series

BELOW (clockwise from left): A Sam3 figure climbs a ladder in Madrid in 2007. // Puking silhouette in Madrid (taken 2007). // A horse relieves itself in Madrid in 2007, while its rider holds on tight. **RIGHT:** A Sam3 figure gets the boot in Madrid in 2008. **FAR RIGHT:** Stretching cat in Madrid (taken 2007). **BELOW RIGHT:** Detail of a large wall piece painted for the 2008 Cans Festival in London.

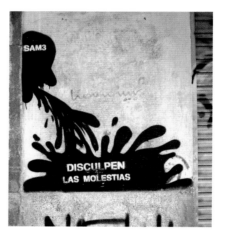

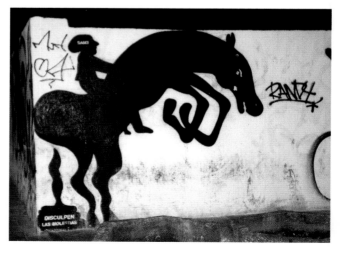

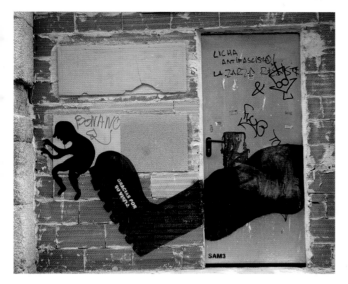

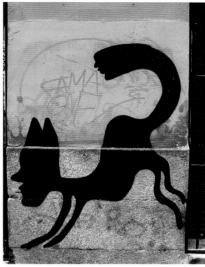

Origami suggested that billboards are nothing more than corporate paper, there to be toyed with. Subverting the most famous billboard shape in Spain – Domecq's massive bull silhouettes mounted on hillsides – he has variously shown emaciated bulls within the shape, or skeletons, a witty comment on Spanish machismo. In 2007 he was more openly political, with some pieces in Bethlehem highlighting the plight of the Palestinians behind the West Bank wall;

one showed a leg crashing through the wall, another a silhouette of an escalator taking people over the wall.

It is with the silhouettes that he developed his iconic style. Reminiscent of early Greek pottery figures, these massive shapes – sometimes five or six storeys high – are strangely satisfying, showing small ant-like men mutating into huge figures, a unique world inspired in part by the brilliant German abstract film-maker Oskar Fischinger, in whose honour Sam3 also created a fabulous animation *Borrachos*. Pushing the envelope further, in 2009 he created a piece of animation from the water splashes and sun in an abandoned swimming pool, probably the first piece of non-graffiti graffito.

The street sculpture work, inspired by Mark Jenkins, has the same wit: the bust of a national hero in Buenos Aires covered with a massive stuffed black dustbin bag, a transparent filled rubbish bag turned into the shape of a penguin, or recreations of CCTV cameras mounted on random poles, keeping an eye on the street.

143

SASU

Sasu creates patterned geometrical paintings. She often works in collaboration with her husband Kami. They work together under the name Hitotzuki, which means Sun and Moon. "It is like the light and the shadow, men and women, they are contrary to one another yet fuse together creating a whole." Based in Tokyo, the two travel internationally and have created large-scale mural works in Berlin, Manchester, Milan, Prague and Honolulu.

Kami and Sasu are part of the Barnstormers collective, founded by David Ellis in 1999. The group is made up of artists from New York and Tokyo who come together annually in Cameron, North Carolina, where they collaborate to create murals.

The first Barnstormers trip to Cameron was in 1999, and saw a group of 25 artists paint "dozens of barns, tractor-trailers, shacks and farm equipment. Consequently, the tiny tobacco farming community became the unlikely Mecca for the urban collective." Other Barnstormers members include Swoon, Steve Powers and Kenji Hirata. The group also create performances and films, including motion paintings.

In an interview with Thaddeus Chang for *Theme* magazine Sasu talks about painting in a setting so removed from the urban environments where her pieces usually fit: "to see our work suddenly appear after a whole day on that tobacco barn in that corner of Cameron, was uncanny, magical, if I say so myself. Our only purpose was the act of painting. As the sun started to set behind our backs in the evening, we thought we should start calling it a day soon. It was my first time on tour, and I was scared of climbing up to the top at first. Painting so high on the barn was a real challenge. Painting became a way to communicate with the new friends and locals we met in different countries."

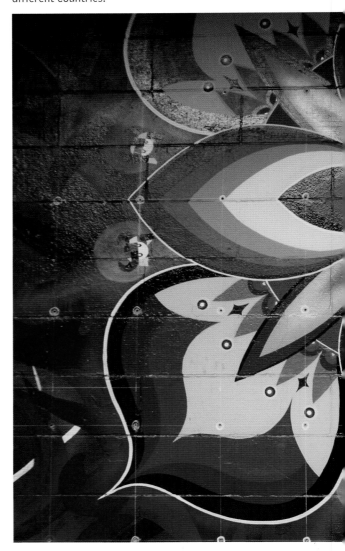

SASU

BELOW: Sasu piece in Yokohama, Japan, part of a mural produced with her husband Kami (taken 2008).

Travel is central to the work Hitotzuki create, with Sasu explaining "You could say our work utilizes the sensations we've experienced, to make one new scene."

"Instead of showing pictures and telling stories about our travels, we feel like it's actually a lot more natural to create a visible manifestation of our experiences with our own hands."

The artists say that their mural and painting works "are expressions formed from our lifestyle and feelings and...also express hope."

SKULLPHONE

Skullphone, the street artist also known as Spazmat, has focused his work on very few images — a robotic skeletal horse, an electro-charged baby and, mostly, the eponymous skull talking into a cellphone. "I've limited my output like a bottle-neck, so I've many times reduced the imagery to Skullphone alone, and the placement is the anchor" he says.

Working in a hoodie on city streets, back lots and deserted highways, his art has mostly been seen on the streets of L.A. and NYC. Sometimes the skull will be seen alone, on ten foot posters raised high on the sides of buildings, sometimes the skull is small, blending into their environment — on parking meters, or incorporated into 'Danger' signage in gas stations.

A favourite of Skullphone's is to post his skull on emptied dumpsters, giving the image a horseman of the apocalypse feel. Skullphone has clearly hit upon some deep neurosis, related perhaps to the feeling that we only feel alive if we're communicating; the image carries a visceral punch.

BELOW LEFT: A pair of iconic Skullphone paste-ups sharing a lower Manhattan window in late 2001. **BELOW:** This location was demolished in 2008 as part of East London's 'above ground' transit project (taken 2005). **RIGHT:** Skullphone evolves with this 3-D 2007 holiday season variant of a glass ornament seen in downtown L.A. (taken 2008).

SKULLPHONE

Having achieved a certain ubiquity on the street, Skullphone has transitioned to the gallery and commercial arena with *nous* and provocation. His website stocks an extensive line of Skullphone merchandise, from prints, t-shirts and tote bags to guitar straps. In 2007 he even designed Christmas decorations, sold in trendy Parisian store Colette and at Tate Modern in London.

The move into the commercial space reached farcical proportions in 2008. Over two days in March, ten of Clear Channel Outdoor's digital billboards in Hollywood, Westwood and Culver City were suddenly showing the cellphone and skull image. The blogosphere went into celebration overdrive, with the news that the biggest name in billboards in the US had been hacked; headlines such as 'Skullphone Strikes Again, Creeps

Out L.A. Commuters' were all over local press. It later transpired that Skullphone had paid Clear Channel for the space.

The blogosphere raged in turn with accusations of hypocrisy and sell-out. *Wired* magazine called it "checkbook culture jamming". Whether this level of self-promotion marks an end to his career as an interesting artist remains to be seen. As a piece of question-raising provocation however, it's brilliant.

BELOW LEFT: A location-specific skullphone: SFO (San Francisco International Airport's designator) as seen in the city's Haight-Ashbury neighbourhood in 2004. **BELOW:** A pair of Skullphones take over this popular corner in East London. This location hosted the second Finder's Keepers event back in 2003 (taken 2005).

STEN & LEX

BELOW: A large portrait with halo found at London's Cans Festival in 2008.

Rome's most renowned street artists, Sten and Lex are two brothers who first came across street art when they were working for the city's cleansing department, buffing walls.

In a rare case of gamekeeper turned poacher, they were hugely inspired and decided to create their own.

Working out of their Rome apartment, and using the rooftop space to collate their big stencilled portraits, their first work was inspired by the hookers, tramps and other characters they used to run into whilst on their early morning cleansing run.

Their distinctive style comes from the particular stencil technique – used by the military to quickly camouflage equipment – that they mastered. The images pasted are huge – sometimes two metres high – and they paste them by night.

From their initial portraits, they now create images inspired by three distinct themes: Catholic iconography and Italian Renaissance imagery, celebrities and films stars from the 1970s and snapshots of Sten's personal life.

There is also one recurring image of a girl in different poses, sometimes with an unlikely medieval saintly halo above her

STEN & LEX

head. There ought to be something weird about having historic images of popes rendered in stencilled bits of street art, but somehow in Rome they don't look at all out of place. Similarly the detailed stencils they have done with fellow artist Lucamaleonte, picturing scenes from Dante's *Inferno*, just look great against the city's peeling plaster walls.

Recently Sten and Lex have made the transition from street to gallery. They have shown at the Avantgarden Gallery in Milan, at Pure Evil in London and took part in the Cans Festival in 2008. They also create large commissioned pieces for the annual Box Festival at Teatro Vascello in Rome, which features the work of new artists in video, art, performance and theatre.

JUDITH SUPINE

Brilliantly provocative and producing unmistakably original work in Williamsburg and Manhattan, Judith Supine adopted his mother's maiden name as a cover, another mark of his originality: "'Supine' is also the birthing position, which is really interesting to me somehow."

Growing up in Bible-belt Portsmouth Virginia, North Carolina, but to hippy parents who pushed him to be an artist, Supine got into graffiti as a teenager through reading articles on artists like Kinsey, Obey and WK Interact in skateboarding magazines. There was no scene in Portsmouth, or in Richmond where he moved, so NYC beckoned, to be followed by London and Amsterdam, before he returned to Brooklyn.

Supine trod an original path early on. Avoiding the risk of being derivative, he was influenced more by what he was reading than what he was seeing, and drugs. And when it came to visuals it was woodcutters who inspired him, like Leonid Baskin. For five years woodcuts and linocuts were his focus, including one

of his penis intertwined with his brother's penis in a heart shape, now hanging in his parent's living room.

The linocuts were big – one of his brother (a fellow artist and he says his biggest influence) 8ft x 4ft which, once finished, snapped in half. That was when Supine decided he was only "going to make shit that takes ten minutes to make."

Supine has shown the technique he now employs on a YouTube video. He typically grabs magazines from a dumpster, cuts out pages or images that instinctively grab his attention, chucks them together for surreal effect, blows them up on the sort of photocopier architects use to enlarge their drawings, then tints them with acid fluorescent colours and finally cuts them out and pastes them on a wall.

The effect is unforgettable juxtapositions of imagery which keep provoking your subconscious, likely some mad psychedelic dream sequence underwater. The effect of the blow-up accentuates the graphic lines in a design, and the use

BELOW and RIGHT:
This series of paste-ups were found high on a wall in Old Street, London in 2008.

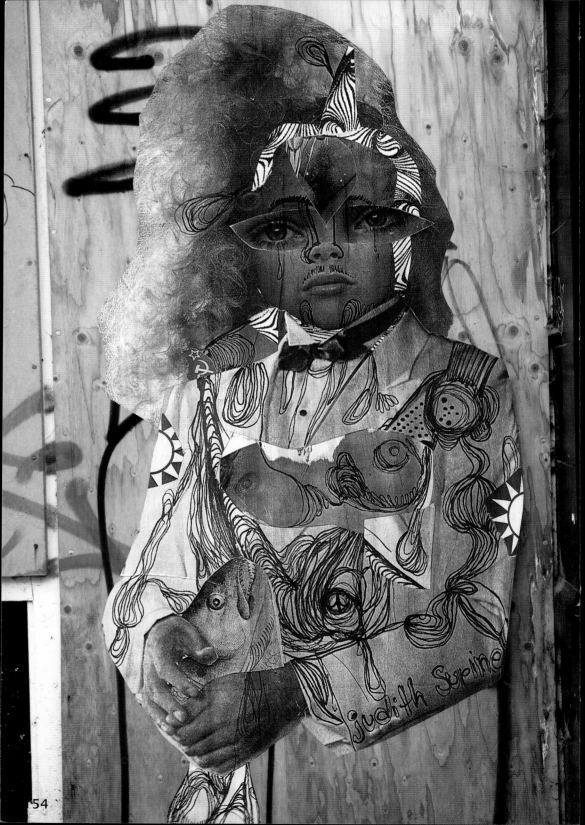

JUDITH SUPINE

LEFT: A black/white poster found at the lower end of East London's Brick Lane in 2007. **BELOW:** This poster was placed high above a doorway in Redchurch Street in Shoreditch, London (taken 2007).

of random photography allows him to mix medieval woodcuts, classical images from the Renaissance and bits of high-gloss contemporary consumerism. For the gallery pieces, Supine painstakingly hand paints around the paper with ultra high-gloss black lacquer paint.

Occasionally Supine will turn political – "there is some shit I will not eat" – as when, in 2006, he wheatpasted a piece on the Times Square Armed Forces Recruiting Station in broad daylight.

He has also pushed the envelope of what street art can be: in 2007 he hung a massive 50-foot artwork in his signature fluorescent colours from the Manhattan Bridge: "it was just something that I thought of when I was

stoned that I thought was funny."

The piece made him internationally famous overnight, and suddenly he was being courted by art galleries and collectors. In 2008 he put a show together for Brooklyn's English Kills Gallery, featuring massive, challenging 12ft high pieces in a warehouse space.

At the same time he continued to create new art in unlikely places, floating a piece – *East River Divers* – showing four women in Victorian swimming costumes diving out of a Benjamin Franklin-type head into the East River, and installing a fluorescent child's head on the figure of a model flashing her breasts, in a muddy stretch of water in Central Park.

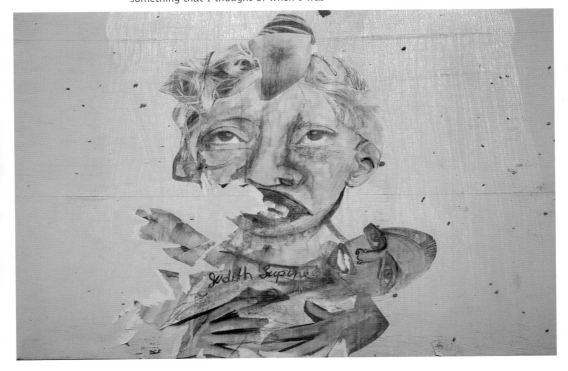

SWOON

LEFT: A large wheatpasted piece in a popular back alley in Shoreditch, London (taken 2008). **BELOW:** A detail of the wheatpaste seen left, showing the intricacy of the design. **BELOW RIGHT:** Detail of a Swoon paper cut-out paste-up found in Gateshead where it was placed as part of the *Spank the Monkey* exhibition at the Baltic, Gateshead (2006).

Swoon produces skilled woodcut paste-ups and cut-outs. They are highly complex and stumbling across them in a street setting always surprises – the amount of work that goes into each piece is amazing. Putting the work up outside means it can be torn down, peeled off or faded by the weather. There is something almost liberating when an artist decides to invest so much in a piece despite no guarantee of permanence. It's as if Swoon is giving a gift to the city with each new work.

After growing up in a small town in Florida, Swoon studied at art school in the Czech Republic and then at the Pratt Institute in NYC, graduating in 2003. She told *Swindle* magazine "My mother's attitude was 'get to New York and everything will start to make sense for you.'"

At Pratt she began creating realist paintings, but felt as if she was going to be forced into producing work for the gallery system. "I began thinking about things that were part of our daily lives but couldn't be removed from it because they couldn't be bought or sold. I became very upset about the commodification of everything that I saw." She moved away from painting and began to produce woodblock prints, and pasted them up around the city, on walls and on top of billboard advertisements. "I wanted to make something that was completely ambiguous and wasn't asking anything from anyone."

She works from photographs to produce wood cuts, lino prints or paper cut-outs, starting with the image before she decides which medium to use, and then producing sketches. She likes the idea of "reflecting the city back onto itself" and the encounters people have with the figures in her artwork.

When choosing what to draw, she looks for a certain moment that she wants to capture "when I draw portraits I'm really trying to capture something really essential about that person, something that I just love, that I have seen in some moment or some gesture...there'll be something that totally obsesses me and I have to figure out what that is and

SWOON

drawing is kind of a way to connect with that. So I try to make portraits that are like me kind of connecting with this subject, and to place them out into the city so that people can witness that moment of connection and have it for themselves."

"I've always really had the sense of the way that people store things inside their bodies and the way that everything that you've ever seen or done is a part of you...and I felt like in a way if I could somehow draw that...almost make like an x-ray of maybe its just your experiences in that day, maybe its what you walked past that day, or maybe its a deeper story that is somewhere in there for the telling."

Swoon has had a number of gallery shows in the last few years, including a group show with Faile and David Ellis, PS1's exhibition *Greater New York*, and the solo show *Drown Your Boats* at New Image Art, L.A.. She says that putting her on-street work up in a gallery is not enough, so she approaches the gallery as a space in which to create work that would not survive in the street – leading to delicate sculptural installations created in paper. Shows have featured textured environments created using cut-out prints strung from walls and ceilings and structures built from wood alongside paste-up images.

She has worked with art collectives the Barnstormers, Black Label, Change Agent, the Madagascar Institute and Glowlab. Her work is in the collection of MOMA, New York and the Brooklyn

Museum of Art. In May-June 2009 she worked with a group of artists on the project *The Swimming Cities of Serenissima* which saw them build 'art boats' from junk, and sail them on the Adriatic sea from Slovenia to Venice, telling "the dreamy story of a drifting metropolis" during the Venice Biennale.

Swoon has spent the last few years travelling and creating exhibitions and workshops in Europe and the US.

Some of her on-street work now features peepholes hidden in urban locations, so that when discovered, viewers get a glimpse of a secret and magical world, another gift to the city.

BELOW: A cut-out paste-up seen near Hoxton Square, London in 2008. **RIGHT (clockwise from top):** An intricately cut-out poster found in Shoreditch, London (taken 2008). // Two early pieces pasted up next to each other in lower Manhattan. The pieces appear hand-made rather than part of a print job (taken 2001).

THE LONDON POLICE

2009 was an exciting year for TLP, a street art collective based in Amsterdam with a changing collection of members. Founding member Chaz moved to Amsterdam from England in 1998. He started creating work in the streets there. Joined by his best friend Bob in 1999, the two decided to work together and The London Police were born. Another member, Garett Chow, joined TLP in 2000, but after working together for three years, Bob left the collective to concentrate on producing his own work. When Garrett left in 2004, Chaz continued to work under the name The London Police alone.

In 2009, Bob (Gibson) and Chaz reunited to celebrate ten years of The London Police with an exhibition "back in their home town" at East London's StolenSpace gallery called *10 Years on the Circle Line*. The exhibition then travelled to Amsterdam and L.A..

The new works the two have collaborated on (for the show and other projects, including a huge wall piece in Amsterdam in June 2009) feature The London Police characters alongside the graphic line work (often featuring densely detailed cityscapes) Bob Gibson has become known for. The mix of the classic TLP style with Bob's work has given the pair a new energy and direction. Sticking to a palette of black and white, but mixing the characters into Bob's environments creates new possibilities for their classic characters.

The characters The London Police paint are referred to by them as 'Lads.' These are printed on stickers or painted on either a people-sized scale at street level or as large-scale murals across the sides of buildings which are painted by crane. Bob says "originally, The London Police was meant to be a creative umbrella, where we would not only be drawing the Lad character, but it would give us an avenue for creative writing or music as well. But with the popularity of the Lad, that became what The London Police were."

Chaz draws the circles that make up the Lad characters freehand, without using compasses or guides. From basic stick-man like beginnings, the Lad has evolved into a clean, bold and instantly

BELOW: Numbers 1 and 6 painted at this Soho (London) fashion retailer as part of a larger 'exhibition' at the store (taken 2003). **RIGHT (clockwise from top left):** Number 4 wheatpasted near the roofline of a Los Angeles retailer on Melrose Ave (taken 2004). // Number 2 sticker in Harajuku Tokyo (taken 2004). // Number 4 as seen in London's Soho (taken 2003). // Number 17 under a window on Standard Place in Shoreditch, London (taken 2003).// Sharing a door in Barcelona's Ciutat Vella (2005).

162

THE LONDON POLICE

LEFT (clockwise from top left): An un-numbered lad painted on a door in Barcelona's Raval (taken 2005). // A large un-numbered lad painted on a street corner in Barcelona's Raval (taken 2005). // Number 90 as a sticker on a wall in Tokyo's Nakameguro neighbourhood (taken 2004). // Number 8 on a Royal Mail label in Shoreditch, London (taken 2003). **BELOW RIGHT:** Mixing it up with an Obey paste-up in the LACMA parking lot in L.A. (2005).

recognisable set of shapes. The figures are so iconic they are now imitated by TLP fans, with Chaz setting aside a section of TLP's website for a photo gallery of the best fake Lads he has seen on his travels.

The circular lines of the Lads, and in the new work, Bob Gibson's angular line drawings (which he creates using a ruler), are impressively clean and precise. Chaz has spend ten years perfecting his art, practicing to make each drawing sharper and tighter than the one before.

He never uses a stencil, but draws every element of the character by hand, drawing perfect circles by imagining that they are the face of a clock, so "if it looks a little bumpy at around three o'clock you have to correct it", using the

tip of the marker as a guide.

TLP have travelled extensively (in 2007 Chaz visited 26 countries in one year) and the Lads have been spotted in Tokyo, Shanghai, Seoul, Barcelona, L.A., New York and Buenos Aires to name a few, although TLP have slowed down more recently, now aiming to do two or three shows a year. In 2009 they planned to work in Istanbul and Kosovo.

On drawing a character that is so instantly recognisable and familiar, Chaz says "It definitely constricts you in some ways. It also builds the significance of the character. There are subtle differences in the evolution of the drawings...I treat the Lad graphic like my friend. Thanks to him, it has paid for my life."

THE TOASTERS

One of the most ubiquitous symbols of London street art, The Toasters, a secretive crew of two artists from the English Midlands, made their first appearance in 1999, marking a transition from tagging to iconographic branding.

At the time the idea of plastering an image of a completely banal household object all over the walls of a city was revolutionary, and The Toasters, together with Invader, were one of the first to grasp the potential power of a repeated brand image in a street art context.

Since then the rigour with which they have pursued their 'brandalism' (a conflation of 'brand' and 'vandalism', a term coined by Banksy) is a lesson in the rigorous use of logos which many a corporation could emulate.

In effect, The Toasters are turning the tables on the corporates' purchase of the street to swamp us with their messages. Claiming the friendliest of kitchen kit as their own, with no attempt to sell us anything, no spin, no side, no marketing fluff, they are suggesting that it's the corporates who are the vandals.

Whilst the essential image of the toaster never really varies – it's always seen from the same angle and is a basic two-slice model, possibly chrome, the context and size do change. Sometimes it's a sticker, at other times a tiny stencil, and occasionally, as at the Cans Festival in London, really big.

In London in 2008 they hijacked a billboard in Holloway, North London, with the logo message 'I Heart Toaster'. The toaster has been breeding all over the world, and has been spotted in profusion in Berlin, Stockholm, New York, L.A., San Francisco, Tokyo, São Paulo, Rio de Janeiro, Montevideo, Buenos Aires, Paris and of course London.

The image is strangely satisfying and only quietly disconcerting. But the logo power is unquestionable – in 2003 it appeared on football banners in England including at Wolverhampton Wanderers games – and in the process achieved

BELOW: A stencil with dripping paint added to the London location for effect (taken 2008). **RIGHT (clockwise from top left):** This wheatpasted poster is a collaboration with Space3, seen in London 2008. // A two-colour stencil with intentional paint drip for effect (taken 2008). //A handmade sticker on a Royal Mail label (taken 2003). // A triplet of toaster paste-ups covering this sign in East London (taken 2003). // Sticker (2003).

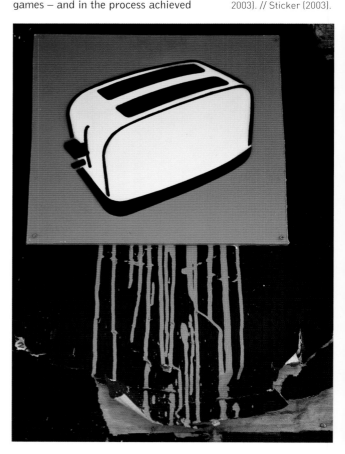

165

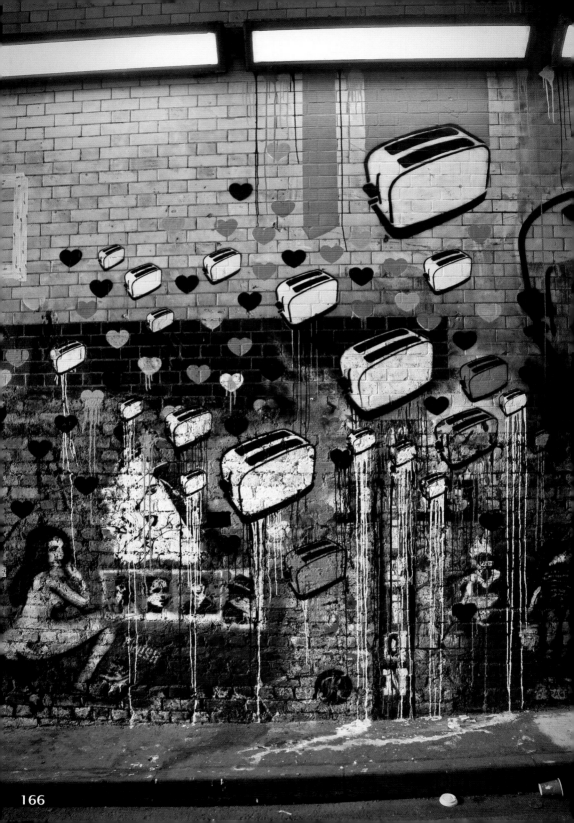

THE TOASTERS

national media exposure.

In 2007 The Toasters held a celebratory show at the Nelly Duff Gallery in London's East End. *Trespassers of the World Unite* was a collaboration with fifteen street artists, including Will Barras, Influenza, Mr. Jago and Late. Several pieces were created for the show, featuring the toaster icon in scenes created by other artists. These included a large acrylic painting with Mr Jago of toasters emerging through a storm and a graphic with Space3.

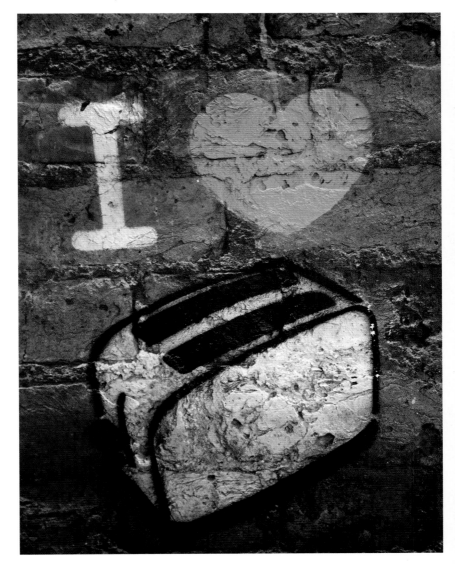

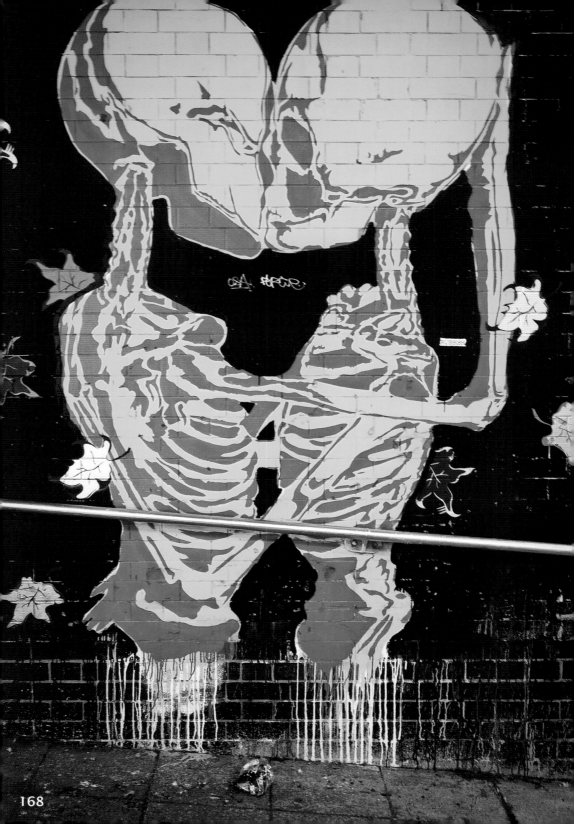

VEXTA

LEFT: *Ghetto Make Out* stencil at the Cans Festival in London, 2008.

Born in Sydney, Vexta did a tour of South East Asia and the Australian outback before moving to Melbourne in 2003 "right when street art was beginning to boom."

Inspired by the scene, Vexta started working with other artists to create 'Empty Shows' illegal art shows in empty, disued buildings.

Her early work was often political in nature, created in protest at Australian PM John Howard's support for Bush's military adventure in Iraq. Works included a stencil of a television screen emblazoned with "The world won't get any better if all you do is sit there and watch" and a stencilled skeleton next to the words "This is what a war victim looks like."

Speaking in advance of a solo show at the Dickerson Gallery, Melbourne, which opened in June 2009, Vexta said: "my early street work definitely has a strong activist element to it because the street can be a powerful place to encourage debate and thought about certain politics and issues, especially when placed in opposition to advertising and its shallow aesthetics."

Her early single-sheet stencil work then developed into more complex, layered stencil portraits created from photographs of friends, and most recently, neon-coloured stencils and paste-ups of skulls, faces and floating figures with brightly-coloured feathers attached to their arms. She says she will continue to produce work for the street, but is also interested in developing

further as an artist and has begun to experiment with more subtle themes, some of which are more suited to the gallery environment.

"I didn't want to be pigeonholed as a political artist so it was a natural progression for me to start exploring themes and stories that hopefully are as relevant today as they were 100 years ago and will be in 100 years to come. Works shown in a gallery context can be gentler because the people viewing them are already open to artistic expression. You have to be bolder on the streets."

Vexta explains her recent interest in using fluorescent colours is because "the only time you find these colours in the natural world are when plants and animals use them to signify danger, yet we consider them 'futuristic.'"

She is interested in exploring sculpture and installation, and for her exhibition at the Dickerson Gallery, created "a nest made of found objects that I have sourced from the city streets."

Vexta participated in the 2008 Cans Festival in London, and produced a piece in collaboration with Broken Crow at the 2008 Kosmopolite Festival in Bagnolet, in the suburbs of Paris, France.

In summing up a way of working, she says: "I like to work quite instinctually. Someone once told me my works are 'quite beautiful but there is always an underlying sense of menace' and someone else said they were 'abrasively beautiful'. I thought both these descriptions were pretty apt."

VHILS

Vhils, a.k.a. Alexandre Farto, creates portraits by scratching and peeling away layers of plaster, metal, brickwork or posters to etch out faces from urban surfaces. He also uses stencils to produce images of cityscapes.

From Seixal, near Lisbon, Portugal, Vhils started working on the streets when he was just 13, tagging and then later creating stencil works, stickers and pieces on trains. He was discovered when he was 16, and now in his early 20s is the youngest of the new street art set represented by Lazarides.

Vhils released a short video to accompany his first solo UK show — Scratching the Surface — at the new Lazarides Gallery at Rathbone Place, London. This shows the artist at work creating a large outdoor wall piece by spraying the shadows and highlights of a portrait onto a wall and then drilling and chipping away at the surface, to expose crumbling brickwork underneath. He sees this as a way of mirroring the decay and destruction that occurs naturally in the city, working to 'reveal' an image that could almost appear to have formed accidentally as time passed. For his gallery pieces and prints, he uses bleach and acid to eat away at paper.

For Vhils, street art is a way of breaking down the rigidity and formality of the city, saying "I look at graffiti and street art as a way to customize this large artificial nest, to try to humanize the streets through colour, forms and the naturalness that has always characterized the human being...

Consider graffiti a city-gray breaker. Human nature stepping out into sight, just like a weed."

In 2009 he participated in Tunnel 228, an art and theatre installation in old train tunnels underneath Waterloo, London, created by The Old Vic Theatre and immersive theatre group Punchdrunk. Artists and actors

BELOW: A close-up of a poster piece created at the Old Truman Brewery, Brick Lane, London to coincide with Vhils' 2009 exhibition Scratching the Surface, at the Lazarides Gallery. **RIGHT:** Two pieces produced for the Cans Festival, London 2008.

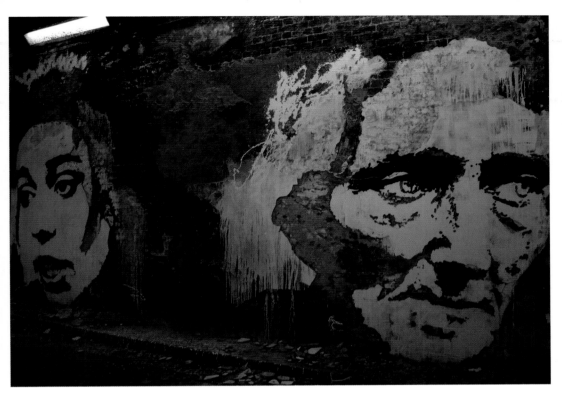

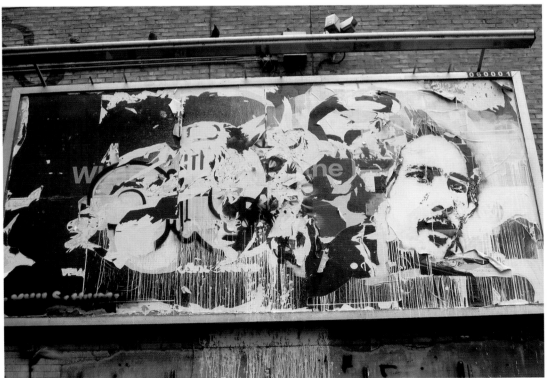

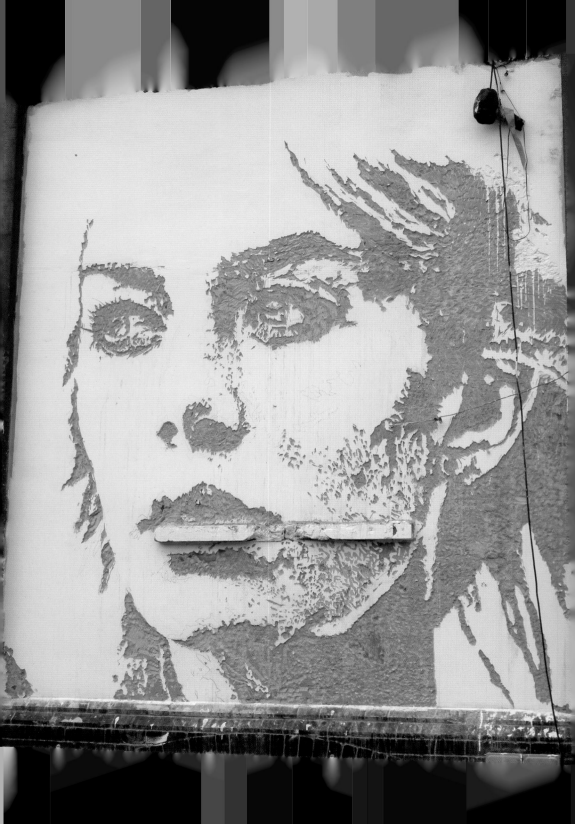

VHILS

LEFT: A female face at the Old Truman Brewery, London, created to coincide with Vhils' 2009 exhibition in the city. **BELOW and RIGHT:** Long view and detail from a poster piece at the Old Truman Brewery, London (2009).

collaborated to portray a dystopian city inspired by the 1927 sci-fi film *Metropolis*. Vhils' piece, a Big Brother-esque face emerging from the tunnel's peeled back brickwork glared over actors portraying workers crawling across the floor. The show also involved artists Mark Jenkins, Slinkachu and Anthony Micallef. The creative director of the Old Vic, Kevin Spacey, said he was inspired by the Cans Festival, organised by Banksy, which took place in another tunnel under Waterloo Station in 2008, which Vhils also participated in.

Vhils appeared in Lazarides' 2008 show *The Outsiders* which opened in New York's East Village as well as in the UK. His first solo show was in 2008, called *Even If You Win The Rat Race, You're Still A Rat* at the Vera Cortes Gallery in Lisbon. For this exhibition Vhils

returned from his focus on the face to "his initial starting point, the city". The show featured projections, video and torn poster pieces of city scenes, where the buildings emerged from the layers of paper in the same way the faces in his recent portrait pieces do.

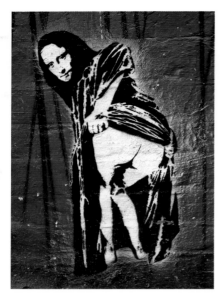

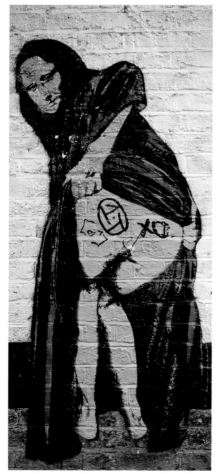

NICK WALKER

LEFT (clockwise from top left): A *Moona Lisa* stencil outside of East London music venue Cargo (taken 2007). // Another view of a *Moona Lisa* stencil outside Cargo, peeping out from behind a pile of bricks (taken 2008). // This stencil of *Apishangel* was put up right outside East London's Cargo café and at the time shared the wall with an Invader from earlier in the year (taken in 2007). // Another *Moona Lisa* outside Cargo (taken 2007). **BELOW** Two pieces next to each other span a pair of shutter doors on Old Street in East London. The right one, a variant of *Ratatouille*, had a heart added by an unknown artist covering up the original stencil of an exploding rat (taken 2008).

One of the wittiest street artists to emerge out of the UK, Nick Walker (a.k.a. Apishangel) started painting graffiti in Bristol over twenty years ago. In 1992 he began using stencils, and, combining this with high-impact splash colours, created an instantly recognisable style, repeating images, motifs and ideas in different contexts.

"I try to add an element of humour or irony to some paintings to add a little light relief to the walls" he says with typical understatement. In fact his images, such as the ultimate British establishment figure – the pinstriped, bowler-hatted, brogue-shod, umbrella-toting City man from the 1950s, hitting a wall with a can of fluorescent in a stack of different contexts are completely hilarious and strangely satisfying.

In the *Morning After* series, the same figure is shown admiring his work as the skylines of London, Bristol, Sydney and New York delineated in hues of grey, are shown dripping graffiti paint from signature buildings. In one New York series, the same figure is shown leaving the scene of the crime in a rowing boat, a strangely lyrical image. *Ratatouille* shows the same figure exploding a rat with a classic 1940s detonation device; in almost time-lapse fashion the rat explodes in a riot of fluorescent, sprayed colours.

For Walker every creative piece starts life in his vast warehouse studio. The stencils are incredibly precisely cut (one repeated image is *Life is Too Short* – an intricate butterfly with glowing coloured wings dropping delicate pigment dust onto a his City man in a rowing boat) and the image carefully composed, before being ready for the street.

Not surprisingly, Walker's art has translated easily to the gallery, and he fetches high prices in L.A., NYC and London. He has also collaborated on reviving a hat range with Kangol. The spirit of fun is always there: The Mona Lisa – as in *Moona Lisa* or morphed into Marge from The Simpsons – is another icon that gets the unique Walker treatment.

DAN WITZ

Born in a smart Chicago suburb, Dan Witz went to RISD before moving to NYC in 1978 to go to the highly prestigious Cooper Union. The black-out and riots had just happened; Punk was on the verge of peaking: "seeing the Clash, the Ramones...the graffiti-bombed trains, the punks on St Marks... art school seemed kind of whitebread and out of touch." These were the days before gentrification when, as Dan puts it: "going for a walk anywhere below 14th Street was an adventure."

Slightly nauseated by the prospect of making his way in an art world dominated by creepy, manipulative white guys in their 50s, Dan decided to exercise his talent on the edge, and in between playing in bands he began

doing street art. Idolising the guys bombing subway trains, recognising that he wasn't from that world, but loving being a contrarian ("I've always been attracted to situations of simultaneous opposites"), he developed the completely surprising tag of a hyper-realistic hummingbird. He painted these life-sized, on the walls below 14th Street, each one taking two hours and drawing curious crowds..."after doing a couple I began to realize what I'd stumbled upon...a monster-load of possibilities I'm still mining." A brilliant artist was emerging

BELOW (clockwise from left): An altered sign in Bushwick, Brooklyn NYC 2007. // Altered sign in Brick Lane, London 2007. // Mixed media piece from the *Ugly New Buildings* series, Greenpoint, Brooklyn 2008. **RIGHT (from top):** Another *Ugly New Buildings* piece, Lower East Side NYC 2009. // Williamsburg, Brooklyn, NYC 2008. // *Ugly New Buildings* series, Brooklyn 2009.

from these near-spontaneous beginnings. But for years life was really tough. "I did street art every summer...but was either touring or too preoccupied with survival issues to sustain any kind of series." In 1994 he developed a second big series – a collection of 70 hoodies on the lower east side entitled *Plague Angels*. He conceived it as a sign of the times, when crime, homelessness, drug-dealing and AIDS were rampant in New York. The success of the piece (he says the idea for the image was instinctive, and he added the theory later, but that it wasn't, as many surmised, an anti-drug polemic) convinced him he should focus on street art full-time.

Already brilliantly original, hugely talented and highly eloquent visually (in any medium he would have made a great artist), Dan took things to the next level, starting to experiment with the layers of faded tagging on walls by adding home-made stickers. The effect was "spatial and surreal", so he began pushing that effect in turn. In 1996, after a summer spent studying old masters in European museums, he hit on his trompe l'oeil airbrush series in what he termed his

DAN WITZ

LEFT (clockwise from top left): A World Trade Centre shrine, Brooklyn 2002. // A piece from the *In Plain View* series, Raleigh, NC 2009. // Close-up of a Bushwick, Brooklyn piece from the 2009 *Dark Doings* series. // Long view of the Bushwick, Brooklyn piece (mixed media on metal door) 2009. **BELOW LEFT:** Mixed media on condo wall, South Williamsburg, Brooklyn 2008. **BELOW RIGHT:** Williamsburg, Brooklyn 2008.

"mosh pit style". He also started at this point on some heavily baroque studio paintings, at a time when the baroque couldn't have been less in vogue – the contrarian again.

There is one common theme in his work however – realism. Rather than treating realism as a jumping-off point to "more expressive and less literal approaches to making art" his jumping-off point is "about trying to make my stuff even more realistic". In so doing he blends old master techniques with new technologies "in fact my street works are more Photoshop than paint". His art has also been completely integrated with the changes in NYC. Pushed out of his

Lower East Side loft by gentrification he moved to Williamsburg, Brooklyn in 2002. 2002 was also the year he did a series of votive trompe l'oeil shrines on street lamps emanating from Ground Zero. After blanketing Williamsburg with his work, he decided that saturation point was being reached, and so went on tour: London, Copenhagen, San Francisco, L.A.. By 2008 much of the working-class and artistic character of Williamsburg had been torn down to be replaced by "cheesy, moderne, luxury condos", but rather than being sentimental about the past, Dan treated these as "new surfaces and settings to work with...that disenfranchisement theme's always a fertile one for me."

Dan is too independent, too clever, too good an artist to have taken the usual route of signing up to a gallery. He now says that the greatest impact on his work has been rising police aggression towards street artists as neighbourhoods get more sanitized: "it's a challenge that keeps me evolving and forces me to lift my game". The most brilliant street artist of his generation? Probably.

WK INTERACT

Born in Normandy, France, WK grew up in St. Paul de Vence, but now lives and works in NYC, where he has been based for over 15 years. WK creates photography-based paste-ups of figures: "movement is the principle focus of all of my work."

WK describes a struggle within his work, between a desire to emphasise the motion of the figures he portrays and to also make the image graphically simple enough for a viewer stumbling across it amid the city's chaos to read. He views each piece as an experiment, which sometimes succeeds and sometimes does not, one of the reasons he often re-uses the same characters, in slightly different poses, or with different parts of their bodies moving "framed captive or wild on the street."

As an 18-year-old WK visited New York and was captivated by the feeling of motion within the city. On returning to the South of France, he attempted to introduce this vibrancy into his work, portraying movement by stretching an image of himself on a motorcycle, enlarging the graphics to life size.

But he found that his work did not fit or make sense in the genteel streets of the South of France. The logical route? To move to NYC. Yet arriving there when he was 21, WK was struck by another problem – he now found it a huge challenge to create work that would have an impact in such a busy location. In order to have an impact on New York, he realised he needed to created big and powerful visuals, work that would exist on a grand scale and compete in a

visually tough environment. It was the toughness of the city that drew him to NYC. Now it has been cleaned up WK finds that he needs to visit Brooklyn in order to reconnect with what he loved about "one of the biggest, gritty cities full of garbage with incredible strength and incredibly strong buildings with something falling apart across the street."

BELOW: Early format poster found in Lower Manhattan, late 2001. **RIGHT:** Paste-up in Barcelona (taken 2007).

WK INTERACT

WK has collaborated with many big brands, including Nike and Adidas, working with sporting figures such as Kobe Bryant and Prince Naseem. This is a marked contrast to his early years in New York, he told *Upper Playground*, in an interview for Walrus TV: "I struggled

for almost six or seven years and I really really struggled, I eat shit for about a year and a half, I lost almost twelve kilos, I used to sleep on the street, I did really tough stuff and I thought it was normal just to stay in New York City and actually its not normal at all...and I got lucky, I got really lucky. "

In 2007 he collaborated with Shepard Fairey on The East/West Propaganda Project (arranged by agnès b.), which saw the two artists produce work together for exhibitions in Tokyo and Paris. For years WK felt his work was too hard to place for him to be considered successful as an artist "basically I was completely out". It refused to fit neatly into either the graffiti, advertising or art scenes. Struggling to carry on living and working in NYC, the emergence of a new street art 'school', into which his bold, location-specific responses to city life fit perfectly, meant that at last WK had a position and presence in the urban art scene.

It is New York, its surfaces and textures, that excite WK "The exciting thing for me is not the final piece, but where I am going to put the piece" as well as the way his pieces interact with other graffiti and street artists' work, and the spaces they share on the city walls.

In addition he values the chance to communicate with the people who see the pieces: "It is so beautiful to touch someone that you may never be able to talk to, this person could be a woman, man or child, and affect them with just a little bit of thought of your own."

CITY SECTION

PHOTOGRAPHS FROM A SELECTION OF KEY STREET ART CITIES AROUND THE WORLD.

BARCELONA

LEFT: Traditional aerosol graffiti with a pasted-up photograph of an old man's face seen in El Raval. Artist unknown (taken May 2005). **ABOVE:** This paste up marches across a door filled with torn posters and faded graffiti (taken 2007). **RIGHT:** Barcelona's most famous cartoon fish shows his hidden alter-ego on this Pez piece on a Raval wall in May 2005.

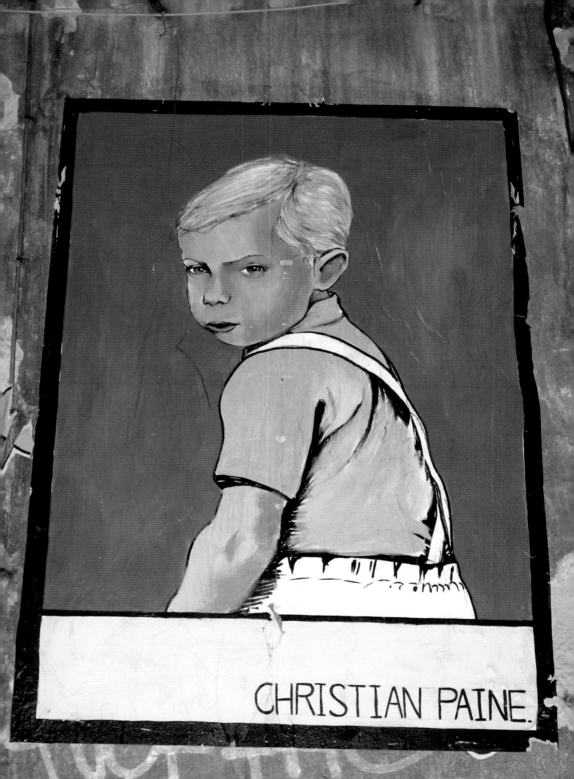

CHRISTIAN PAINE.

BERLIN

LEFT: A Christian Paine piece (taken 2007). **RIGHT (clockwise from top):** A paste-up by an unknown artist (taken 2008). // Two owls roost in this Berlin doorway in 2008. // A colourful Various & Gould paste-up (taken 2008). // A female figure by Berlin stencil artist XOOOOX (Jan 2007).

LONDON

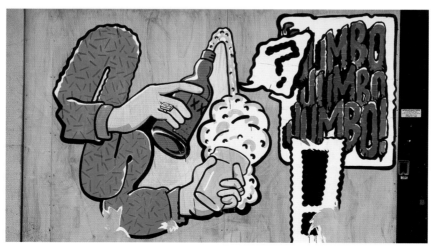

ABOVE: A selection of Cartrain framed collage pieces, taken 2008 in Shoreditch. These are firmly attached as can be seen where 'admirers' unsuccessfully tried to acquire the pieces. **LEFT:** Australian artist Mr. Jumbo pasted this colourful piece on a Shoreditch wall (taken 2008). **RIGHT:** A poster that was part of Stephen Gill's 2007 *Hackney Flowers* street exhibition around East London (taken Sept 2007).

Hackney Flowers, Stephen Gill 2007

LONDON

LEFT (clockwise from top): Woodcut-like graphic of a crow pasted-up near Old Street in East London (taken 2009). // Piece by Greek artist The Krah (taken 2008). // A pair of pieces by East London's Xylo. The first makes a statement about the proliferation of CCTV. The second, printed on the financial pages of a newspaper, shows a plane flying into London's 'Gherkin' building (taken 2009).
RIGHT: This large black & white poster of a building facade with '1930' in neon blue was captured on a wall across from Smithfield Market in April 2007.
BELOW: Dotmaster's *Sorry* piece, seen in Shoreditch, May 2008.

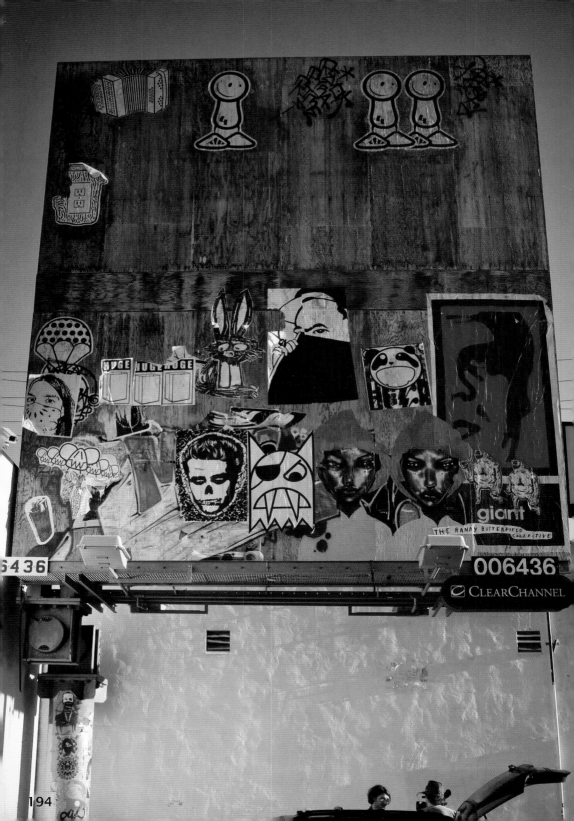

LOS ANGELES

LEFT: Pieces by Shepard Fairey, Ryan Graeff, Buff Monster, TLP, and others can be seen sharing this billboard in L.A.'s Sawtelle district next to the Giant Robot 2 store/gallery (January 2008). **RIGHT (clockwise from top):** Gaia paste-up found in L.A.'s downtown Artist District, January 2008. // This poster of a green rooted hand was found pasted-up over some graffiti on a downtown wall in January 2008. // Anti-war motif by 2 Cents found in L.A.'s downtown Artist District, January 2008.

MADRID

LEFT: Paste-ups from the Madrid Poster Art festival in 2009. **BELOW:** Painted piece by Jorge Rodríguez-Gerada in an empty lot on La Plaza de San Ildefonso (taken 2007). **BELOW RIGHT:** Remed and Tatone paintings on La Calle del Pez (taken 2008). **TOP RIGHT:** Remed and 3ttman mural on La Calle de la Luna (Feb 2009).

197

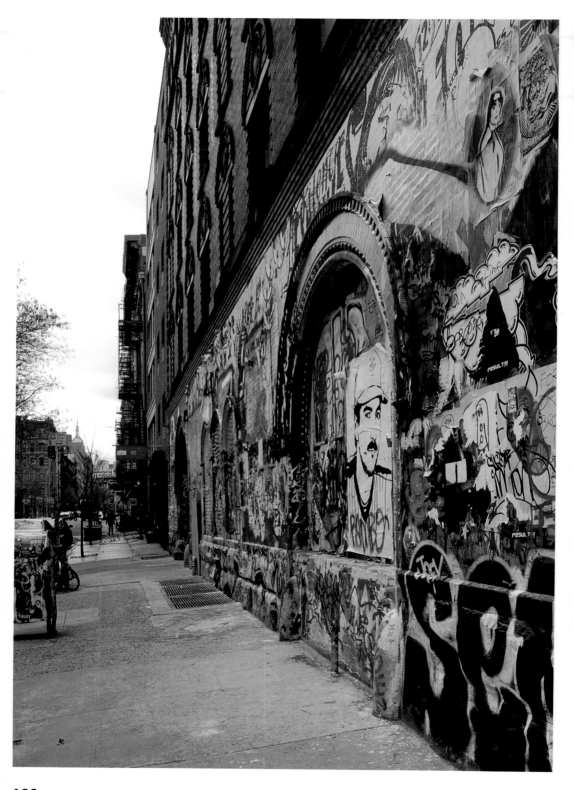

LEFT and RIGHT:
New York street art
destination 11 Spring
Street (taken 2007).

SAN FRANCISCO

LEFT (clockwise from top left): A sticker of Mars-1's 'Observer' character near Folsom Street (taken 2006). // A sticker found downtown (taken 2004). // A collaboration with another artist in San Francisco's Mission District. This 'character' was made into a limited edition vinyl toy (taken 2005). // Detail from a mural found on an alleyway in San Francisco's South

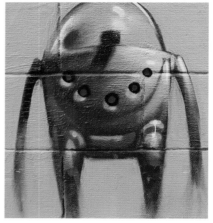

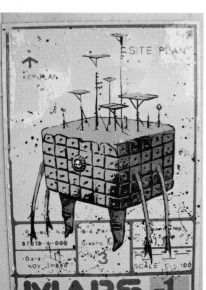

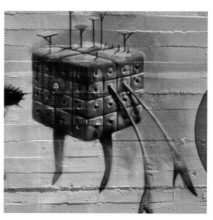

SAN FRANCISCO

of Market district (taken 2003). // An example of a Mars-1 robot seen in an alleyway near the train depot in downtown San Francisco (taken 2002). **BELOW:** A set of *Abraham Obama* posters placed in a San Francisco alley during Ron English's West Coast campaign tour in August 2008. **RIGHT:** Two hand-painted pieces by Dave Warnke seen on a wall in San Francisco's Mission

TOKYO

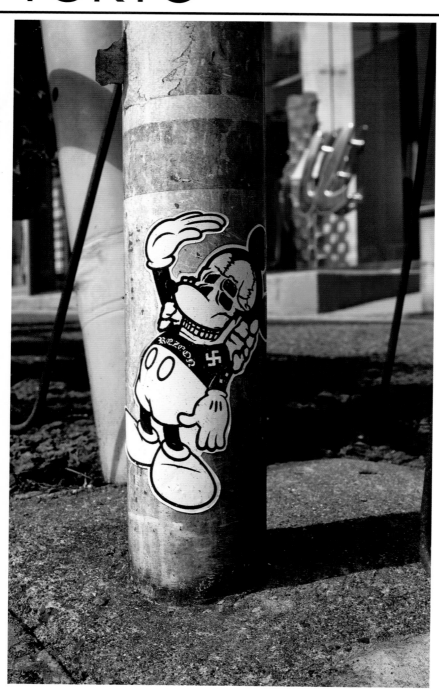

LEFT: This sticker of a Mickey Mouse derivative acting quite Nazi-like was captured laying low on a street pole in Tokyo's Daikanayama area (taken August 2008). **RIGHT (clockwise from top left);** "This is street art" or so we're told by this wheatpasted face on a Nakameguro, Tokyo sign (taken Aug 2008). // Looking up Lady Liberty's bronze robe on this sticker which was found throughout Tokyo in August 2008. Is this a picture of the real statue in NYC or is it a miniature replica in Tokyo? // This sticker of a kabuki-like face was found in Shibuya, Tokyo (taken Aug 2008). // This elaborate cartoon-like poster by an unknown artist found a home next to an old Faile skull stencil on a Tokyo wall (taken August 2008).

TOKYO

CREDITS

WRITING CREDITS

Eleanor Mathieson: EM
Xavier A. Tàpies: XT

Above	XT
André	EM
Banksy	XT
Bäst	EM
Blek	XT
Blu	EM
Bo130	XT
Bs.As. Stencil	XT
Btoy	XT
Buff Monster	EM
C215	EM
James Cauty	XT
Civilian	XT
Cut Up Collective	EM
D*Face	EM
Dolk	XT
Eelus	XT
Eine	EM
Elbow Toe	EM
Eltono	XT
Esow	XT
Ethos	XT
Evol	EM
Faile	EM
Shepard Fairey	XT
Conor Harrington	XT
Logan Hicks	EM
Insa	XT
Invader	EM
Jef Aerosol	EM
Mark Jenkins	XT
JR	EM
Kami	EM
MBW	XT
Barry McGee	XT
Lucy McLauchlan	EM
Microbo	EM
Miss Van	EM
Os Gêmeos	XT
Prefab 77	EM
Pure Evil	EM
Roadsworth	EM
Sam3	XT
Sasu	EM
Skullphone	XT
Sten & Lex	XT
Judith Supine	XT
Swoon	EM
The London Police	EM
The Toasters	XT
Vexta	EM
Vhils	EM
Nick Walker	XT
Dan Witz	XT
WK Interact	EM

Eleanor Mathieson and Xavier A. Tàpies are the authors of *Street Art and the War on Terror: How the World's Best Graffiti Artists said NO to the Iraq War*, published by Graffito Books Ltd., London.

Check the Graffito Books website for street art articles, videos and new photography.

www.graffitobooks.com

PICTURE CREDITS

Glenn Arango is the photographer for *Street Artists: The Complete Guide*. All of the photographs in the book were taken by Glenn unless listed on page 207.

GLENN ARANGO

Originally from Chicago (by way of Medellín), Glenn Arango has travelled the world for the past ten years photographing street art in the world's major urban centres, including London, Barcelona, Hong Kong, Los Angeles, Tokyo, and New York. He is now based in the San Francisco Bay Area where he works in the internet industry.

CREDITS

LEFT: A pair of colourful TLP characters on a wall in East London. The appearance of these stickers around London coincided with the TLPs 10th anniversary show in April 2009.

Front cover: Kevin Mathieson p17 Banksy *Hoody* at Cans Fest, Kevin Mathieson; p19 Banksy *Buddha* at Cans Fest, Kevin Mathieson; p27 all photos Eleanor Mathieson; p29 Eleanor Mathieson; p30 Eleanor Mathieson; p31 Guillermo de la Madrid escritoenlapared.com; p34 all photos Kevin Mathieson; p50-51 HowAboutNo! flickr.com/photos/howaboutno; p52 D*Face *Airborne Cavalry*, Eleanor Mathieson; p54 *Her Royal Hideous*, Eleanor Mathieson; p57 three Dolk stencils in Lisbon, Eleanor Mathieson; p58 two Dolk stencils in Lisbon, Eleanor Mathieson; p65 Eine on 333 Club, Eleanor Mathieson; p70 Guillermo de la Madrid escritoenlapared.com; p71 Eltono in Zaragoza, Guillermo de la Madrid escritoenlapared.com; four Eltono pieces in Madrid, Brocco Lee flickr.com/photos/brocco_lee; p72 Eltono in Madrid, Brocco Lee flickr.com/photos/brocco_lee; Eltono in Monterrey, Jose Fidencio Constantino flickr.com/people/fidencioconstantino; p73 Eleanor Mathieson; p74 i suqe flickr.com/people/isuqe; p75 Ashley Arnold; p76-77 Andre Oba obaart.com; p78-79 evol/ctink evoltaste.com; p83 Faile *Bunny Boy*, Berlin paste-up, Old Street, Eleanor Mathieson; p92 Ian Castello-Cortes; p98 all photos Eleanor Mathieson; p104 Kevin Mathieson; p105 Eleanor Mathieson; p106 wetwebwork; p107 Olof Werngren; p111 Eleanor Mathieson; p119 Barry McGee face in San Francisco, Dan Carlson flickr.com/photos/petalum; p120-121 Dan Carlson flickr.com/photos/petalum; p122 Eleanor Mathieson; p129 Eleanor Mathieson; p131 Eleanor Mathieson; p134-136 Prefab 77; p138 *Wage Increases* stencil, Kevin Mathieson; p140-141 all photos Ian Rogers greynotgrey.com except Scissors stencil, by Hobbes flickr.com/people/hobbes313; p142-143 all photos Brocco Lee flickr.com/photos/brocco_lee except Cans Festival photo, by Eleanor Mathieson; p144-145 Chisato Kaizuka flickr.com/photos/chichacha; p150 Kevin Mathieson; p152-153 all photos Eleanor Mathieson; p157 Octopus cut-out Eleanor Mathieson; p163 Dan Carlson flickr.com/photos/petalum; p170-171 top right Cans Fest photo by Kevin Mathieson, all other photos by Eleanor Mathieson; p172-173 all photos by Eleanor Mathieson; p174 *Moona Lisa* behind bricks by Eleanor Mathieson; p176-179 all photos Dan Witz danwitzstreetart.com; p181-183 all photos Eleanor Mathieson; p184-185 all photos by Eleanor Mathieson; p187 top right photo by Eleanor Mathieson; p188-189 all photos Eleanor Mathieson; p192 The Krah photo by Eleanor Mathieson; p196-197 all photos Guillermo de la Madrid escritoenlapared.com; p198-199 all photos Christopher Fleming.

ACKNOWLEDGEMENTS

Graffito Books would like to thank all of the artists whose work features in *Street Artists: The Complete Guide* for bringing life and colour to the streets. In addition, huge thanks to all of the photographers who have contributed images to the book, in particular Glenn Arango, whose fantastic collection of street art images has made this book possible.

Special thanks also to Guillermo de la Madrid, Christopher Fleming and Kevin Mathieson for allowing us to include their photographs.